The Lettershop™ Calligraphy Project Kit

By Joanne Fink and Cheryl O. Adams

The Lettershop™ Calligraphy Project Kit

By Joanne Fink and Cheryl O. Adams

Published by
Hunt Manufacturing Co.
Statesville, NC 28677

Book Design
Deborah Cunningham and Lance Turner
Calligrapher's Ink, Lake Mary, FL

Calligraphy
Cheryl O. Adams
Adams Art, Des Moines, IA

Cover Design
Helen Major
Hunt Manufacturing Co., Philadelphia, PA

Proofreading
Maura Cooper
Dancing Letters, Charlotte, NC

Typography
Adobe Minion and Tekton

Wirebound Book ISBN 0-9631532-1-8
Hardbound Book ISBN 0-9631532-2-6

Table of Contents

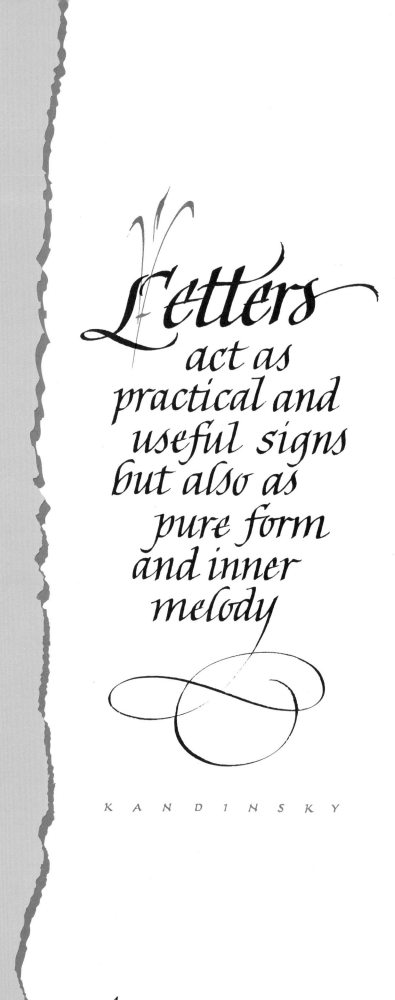

Letters
act as
practical and
useful signs
but also as
pure form
and inner
melody

K A N D I N S K Y

Introduction

This book is designed for anyone who wants to learn the basics of italic calligraphy, and then use calligraphy to letter beautiful invitations and greeting cards, and address elegant envelopes. The first part of the book will teach you how easy it is to get started— and what kind of tools and materials you'll need to practice. It also includes helpful hints for setting up your work area and beginning your calligraphic study.

✕

Section two is a step-by-step approach that will help you learn the italic letterforms and their relationships to one another. This section features detailed explanations of how to draw each letter, and exercises that will make it easy for you to begin mastering the art of beautiful writing. One of this section's goals is to give you a clear understanding of the shape, structure, weight, and spacing of italic letterforms so that you'll be able to write the alphabet with rhythm, beauty and panache.

✕

Section three begins with information on layout and design, which should prove helpful when you start working on the projects in this section— addressing envelopes, designing invitations and greeting cards.

✕

The last part of the book has a variety of detachable practice exercises and lining guides for you to use when practicing your lettering and working on projects.

✕

This kit is unique in that it contains all the materials you'll need to get started learning calligraphy— pens, paper, ink and instructions. You will have to spend time practicing in order to master the alphabet. The more frequently you practice, the faster your calligraphic skills will develop.

Tools & Materials

The italic hand developed during the 15th century Italian Renaissance. Its elegant, versatile letterforms make italic a popular style with many contemporary calligraphers. Once you learn the alphabet you'll be able to address envelopes, design your own invitations and greeting cards and much more. But before putting pen to paper, you need to know about the calligraphy supplies you'll be using.

Relatively few materials are needed to begin making letters; with paper, pen and ink the world of calligraphy is available to anyone who is interested and willing to practice. In addition to the supplies that come with this kit there are other tools and materials that may come in handy when you are setting up your work area.

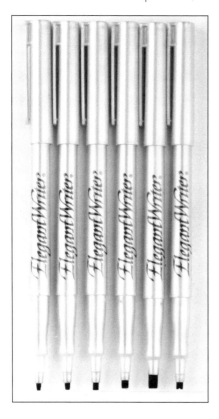

MARKER PENS

The *Elegant Writer®* calligraphy markers, which are included with your kit, have crisp, chisel (broad-edged) tips and are available both with water-soluble and permanent inks. *Elegant Writers* have a unique feature— a child-proof safety cap. They come in a variety of colors and nib sizes and are convenient to carry around.

FOUNTAIN PENS

Panache® fountain pens are also a good choice for beginners as they have a cartridge which automatically feeds ink to the nib. The cartridges come in several colors, and the nibs are available in six different sizes. *Panache* nibs are also made for left-handed scribes.

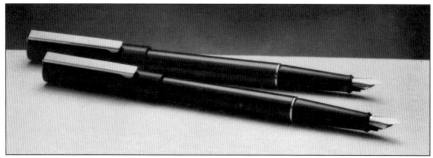

DIP PENS

There are two different kinds of dip pens— pointed, flexible nibs and broad-edged tools. Both can be inserted into the *Speedball®* pen holder. When lettering italic, select a broad-edged tool like the C-series *Speedball* nibs. When you study copperplate calligraphy you'll need a pointed nib like the *Hunt 99* or *103*.

INKS AND PAINTS

Water-soluble and waterproof inks are manufactured in a wide array of colors. When using your *Panache®* fountain pen, use only the *Panache* fountain pen ink. When using a dip pen, try a bottled ink. Many advanced calligraphers like to control the denseness and darkness of the writing fluid by grinding Chinese stick ink. For color work, gouache (a type of watercolor with chalk added for opacity) is the preferred medium.

PAPER

The type of paper you select is critical to good lettering so it is important to choose a paper that will work well with your pen and ink. *Bienfang®* 19 lb layout bond is an excellent, economical choice. For finished work try *Bienfang* smooth or vellum surface Bristol Board, or any good quality machine or handmade paper. *Panache* cards and envelopes are great to use when lettering invitations and greeting cards. Be sure to test your paper (or envelopes) with the pen and ink you want to use before doing a large project. Some papers "bleed"— absorb ink too quickly; other papers may have a coated or shiny surface which can be difficult to work on.

RULER & T-SQUARE

A clear (see through) T-Square and a metal ruler with a cork back to prevent slipping are both invaluable tools for measuring and drawing lines. Both rulers and T-Squares come in different sizes. If possible, get these tools slightly larger than the paper you plan to use.

WORK SPACE

A well-lighted working surface is essential to produce good calligraphy. Many calligraphers prefer an adjustable, slanted drawing board while other calligraphers are comfortable working on a flat surface like a table. You may wish to experiment to find out which works best for you. Whatever type you choose, make sure you have good lighting and a comfortable chair to ensure good posture.

ADDITIONAL EQUIPMENT

Other recommended supplies include pencils (a 3H or 4H is the perfect choice to draw lines), tape (both removable and artist's tape), adjustable triangle, eraser (white plastic or kneaded), light box, water container and a rag or soft paper towels for cleaning nibs. Access to a photocopier that enlarges and reduces is also recommended for serious students and scribes.

Calligraphic Terms

Before beginning to do calligraphy it is important to understand some of the terms used to describe different parts of the letters. Please read the following definitions carefully, and look closely at the diagrams. You may wish to refer back to them as you continue your studies.

Ascender *The portion of a lower case letter that rises above the waist line.*

Ascender line *The guideline showing the height of an ascending letter. In italic, the ascender line is at 9 nib widths above the base line.*

Base line *The writing line that the body of a letter sits upon.*

Branching stroke *The stroke which connects an arch to the downstroke of a letter.*

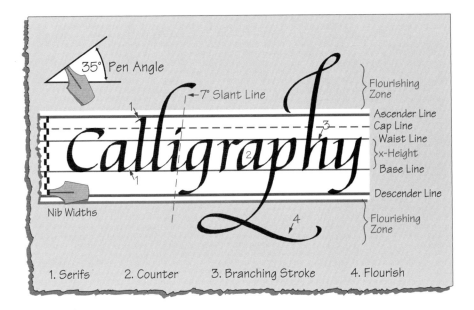

35° Pen Angle

7° Slant Line

Flourishing Zone

Ascender Line
Cap Line
Waist Line
x-Height
Base Line

Descender Line

Flourishing Zone

Nib Widths

1. Serifs 2. Counter 3. Branching Stroke 4. Flourish

Cap line *The guideline showing the height of a capital letter. In italic, the cap line is at 7 nib widths above the base line.*

Counter *The (white) space inside a letter.*

Cross bar *Horizontal stroke forming part of a letter (such as the t or H).*

Descender *The portion of a letter that falls below the base line.*

Descender line *The guideline showing the length of a descending letter. In italic, the descender line is at 4 nib widths below the base line.*

Downstroke *A stroke directed downwards towards the base line or descender line.*

Ductus *The number, direction and sequence of the strokes which make up a letter.*

Flourish *A non-structural embellishment added to a letter.*

Hairline *A very thin line.*

Majuscule *A capital, or upper case letter.*

Minuscule *A lower case letter.*

Nib *The pen point.*

Nib width *The width of any broad-edged nib. A letter written at 4 nib widths high will appear twice as heavy as one written at 8 nib widths high with the same pen. Italic lower case x-height letters are written at five nib widths.*

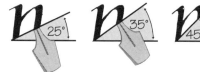

Pen angle *The angle at which the nib meets the paper, relative to the base line.*

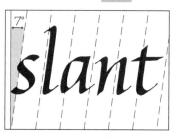

Pen scale *The height of the letter measured in nib widths of the pen being used. Italic lower case x-height letters are written at five nib widths, and ascenders at nine nib widths.*

Serif *A small stroke which begins or ends a letter or a part of a letter.*

Slant *The slope of a letter, measured from the vertical.*

Slant line *The guideline showing the correct slant. Italic is written at a 7° slant, measured from the vertical.*

Spacing
Counter Space: space inside a letter
Interletter Space: space between letters
Interword Space: space between words
Interlinear Space: space between lines of writing

Thick *A heavy or blunt stroke.*

Thin *A fine stroke, sometimes called a hairline.*

Waist line *The guideline showing the correct position for the upper boundary of the x-height.*

x-height *The height of a letter or the portion of a letter that sits between the base line and the waist line (the height of the lower case x).*

Lettering Preparations

Before starting the practice exercises described in the next section, read this section on how to set up your work area and prepare your tools.

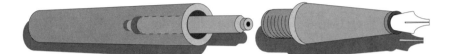

To use your marker all you'll need to do is take the cap off. To use the fountain pen you'll have to insert the ink cartridge, colored end first, into the barrel (see diagram above). Then screw the nib onto the barrel. Once the pen is assembled, make practice strokes until the ink starts to flow. This should take no more than a minute. When you are not using your pen be sure to keep the cap on. If you ever forget and leave the cap off, you may need to dip the nib in water or wipe it with a damp paper towel in order to get the ink to flow again. Store your pen with the point up. Whenever you change nibs, you'll want to rinse the nib out with pen cleaner or running water and dry it with a soft lint free rag or paper towel.

At the back of this book you'll find a variety of practice exercises and lining guides. Each one is clearly marked with the name of the pen (*Panache®* and/or *Elegant Writer®*) and the nib size. Make sure that you match your pen size to these sheets. When doing the exercises you'll want to write directly on the sheets provided. When using the lining guides, you can either write directly on them, photocopy more for future use (you can tape two photocopies together when you need wider lines) or tape a sheet of layout bond on top of the lining guide and use it as an underliner. It's a good idea to practice with a large size nib because you'll be able to see the shapes you are making more clearly.

Before beginning to do calligraphy you'll need to set up an area in which to work. While there is nothing wrong with the kitchen table (assuming you have a good source of lighting there), it

would be preferable to find a space where you can leave your calligraphy supplies set up. You will make the most progress if you practice for at least half an hour (an hour is even better!) several times a week, and it is certainly easier to do this if you have a place ready and waiting for you. Try to pick a time to practice when you are not too tired, because calligraphy takes concentration. If possible, it would be best to schedule your practice sessions when you are not likely to be interrupted by the telephone, family members or other distractions.

When you practice, remember that you'll make better progress if you are comfortable in your work space. This means good lighting (most calligraphers have a flexible-necked lamp attached to their drawing board or table) and a comfortable chair to sit on. You might like to have a separate table next to your writing surface on which you can keep your other supplies. If space permits, you can make photocopy enlargements of the exemplars in this book to hang on the wall where you can see them as you practice.

The broad edge or chisel edge of your calligraphy pen will create thick and thin lines depending on the direction you move it. When lettering, aim for smooth, even strokes with crisp, clear edges. In order to avoid ragged-edged letters, hold the pen lightly but firmly between the thumb and the first two fingers, and keep the nib edge flat to the paper. It is helpful to pad your writing surface with a few sheets of paper to allow the pen nib to have some spring.

Keep a piece of scrap paper, used for making test marks, next to your writing paper. This will help you determine and control the ink flow and pen angle before writing on your good sheet. You should always use a "cover sheet"— a sheet of paper that you place on top of your paper, just below the writing line, to keep it clean. Not only will this protect your page from dust and other dirt but also from the oils on your skin. These can leave a film on the paper, making it difficult for the ink to adhere to the paper's surface. Using scrap paper and a cover sheet are good habits to get into right from the beginning of your calligraphic career.

Pen Patterns

These pen pattern exercises will help you become familiar with and comfortable using a broad-edged pen. They will also help you practice holding the pen at a 35° angle, which is very important when lettering the italic alphabet.

Before starting the exercises, you may want to experiment moving your pen in different directions to see which strokes will be thick and which will be thin. Then pull out the pages marked Practice Exercise 1A and 1B from the back of the book. There are two lines given for each pen pattern. On the first line you should trace over the ghosted images, and on the second line draw the patterns on your own. If you'd like extra practice, photocopy the exercise pages before writing on them.

You'll find that it is easier to pull rather than push a stroke, particularly with a pen, which is why you might find it easier to work with a marker pen than a fountain pen when you are just beginning to learn calligraphy. Do these exercises using a broad or scroll *Elegant Writer*® marker. If you want to practice with your *Panache*® fountain pen, it would be a good idea to repeat these exercises using the broad nib before going on to make letters. As your skill develops you'll enjoy the crisp edges and control that using pen and ink permit.

Try to keep your pen shapes consistent and evenly spaced. Practicing these repetitive movements will help you develop a rhythm and consistent flow. Many of these patterns can be used as decorative elements or border designs on invitations, greeting cards and other creative projects.

Italic Lower Case

Most letters are made up of more than one stroke. Unlike handwriting, you may want to think of calligraphy as drawing, or carefully constructing each letter. The arrows in the diagram below show you the ductus, or stroke order and direction, in which each of the letters is written. You might want to refer back to this page once you are ready to work on your calligraphic projects.

a b c d
e f g h i j
k l m n o p
q r s t u v
w x y z

Before you begin writing, study the letterforms on this page closely. Look carefully at the serifs and try to determine how each letter starts and ends. Lower case italic letters are written at an x-height of 5 nib widths, with the ascending letters at 9 nib widths, and the descending letters at 4 nib widths below the base line. Keep your nib at a 35° angle, and slant the letters 7°.

Skeletal Forms

Before using the broad-edged calligraphy pen to make letters, it's beneficial to learn the letter shapes by studying the skeletal or monoline forms which make up their underlying structure. Using a pointed tool, such as a pencil or ball point pen, trace the letters below to familiarize yourself with their forms. Knowing what italic letters should look like without their thicks and thins will make it much easier for you to draw the letters with your calligraphy pen.

abcdefgh
ijklmnopqr
stuvwxyz

Counter Space

In order to really understand a letter's shape it is important to recognize the counter space (white area) around and inside the letter. Take some time to study the shaded areas in the letters below. Note the similarity between the shapes inside the *p* and *b*, and the *a* and *g*. If your eye can clearly see the counter shape of the letter, it will be easier to draw the letter itself.

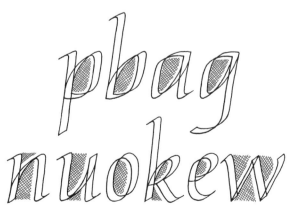

Letter Groups

Dividing the lower case italic alphabet into different family groups will help you understand how the letterforms relate to one another. For each letter group there are printed exercise sheets at the back of the book. The exercise sheets give you two lines to practice each letter; the first line has ghosted images of the letter for you to trace, and the second line is for you to practice making the letter on your own. Before doing the exercises, be sure to read this section on how to form the letters.

Try to make each letter following the steps listed in the description. You should use the broad nib to do the exercises. After you feel comfortable with their shapes you may want to practice the letters using smaller nibs and corresponding lining guides.

Straight

The first group of letters is covered on practice exercise sheets 2A and 2B at the back of the book. When you practice pay special attention to the entry and exit strokes (serifs) of the *i*, since most of the italic alphabet uses these same strokes.

i l t f j

To write the letter *i*, put your pen just below the waist line and then move it upwards at a 35° angle so you get a thin entry stroke to the letter. When the top right corner of the nib hits the waist line, move the pen in a tight curve to the right so you get a soft rounded top to the *i*. (Study the exemplar in the box to the left to be sure that you don't make this top too sharp and angled or too wide and rounded.) Then pull the stroke down along the 7° slant line. Just before reaching the base line, make a tight turn to the right and end with a hairline serif. Remember your pen should still be held at a 35° angle. The dot on the *i* is formed by placing your pen at seven nib widths above the base line and pulling down along the slant line to make a small rectangular shape above the letter. Make sure the dot is no longer than one half nib width.

To write the letter *l*, place your pen just below the ascender line and then move it upwards at a 35° angle so you get a thin entry stroke to the letter. When the top right corner of the nib hits the 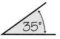 ascender line, move the pen in a tight curve to the right so you get a soft rounded top to the *l* (just like the top of the *i*). Then pull the stroke down along the 7° slant line. Just before reaching the base line, make a tight turn to the right and end with a hairline.

To write the letter *t*, put your pen above the waist line— between the sixth and seventh nib widths. Pull straight down along the slant line until you've almost reached the base line. Then move your pen in a gentle turn to the right and end with a hairline. The *t* should have a wider, more rounded bottom than the *i* or the *l*. For the crossbar on the *t*, place your pen so that the right corner of the nib just touches the waistline, about one nib width to the left of the downstroke. Move the nib straight across the waist line until the crossbar on the *t* is as wide as the rest of the letter. The crossbar always hangs below the waistline.

The letter *f* is drawn in three strokes. Start by putting your pen below the ascender line—at the eighth nib width—and move it down to the left so the letter begins with a thin line. Then pull the stroke down along the slant line, and end it the way you'd end an *i* or *l*. To draw the top of the *f*, put your pen back *on top* of the thin line that started the first stroke. Move the nib up to the right so that your new stroke totally overlaps the first one. Continue moving to the right in a gentle curve, and end just below the ascending line. The crossbar is the same as the crossbar for the *t*.

The letter **j** begins the same way as the letter **i**, but you'll need to bring the stroke straight down along the slant until the second nib width below the base line. Then you'll move the pen to the left, still keeping the pen at 35°, so that you end the stroke on a thin line at about the third nib width below the base line. Pick up the pen and move it about two nib widths to the left. Put it just above the descender line and draw a gentle curving stroke that overlaps the thin line from the first stroke. The rounded part of the **j**

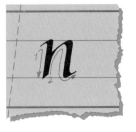

should just hit the descender line. The bottom of the **j** and the top of the **f** should mirror each other. You can check your success by turning the page over to see if they match. The dot on the **j** is the same as the dot on the **i**.

Branching 1

This next group of letters all share a common feature—the branch. Like a tree branch which is thicker closer to the trunk, a letter branch will be slightly thicker near the downstroke of the letter, before it tapers to a thin line. To practice this group, pull out exercise sheets 3A, 3B & 3C from the back of the book.

n m h b p k r

To write the **n**, begin as if you were lettering an **i**—by placing your pen just below the waistline, and then moving it upwards at a 35° angle so you get a thin entry stroke (serif) to the letter. When the top right corner of the nib hits the waist line, move the pen in a tight curve to the right so you get a soft rounded top to the **n**. (Study the exemplar to be sure that you don't make this top too sharp and angled or too wide and rounded.) Pull the stroke down along the 7° slant line until you reach the base line, and then pause. The bottom of your stroke should just pierce the base line. Next, push the pen up along the line you've just

drawn until you get about two thirds of the way (to 3 1/2 nib widths). Then begin branching out by continuing to move your pen in an upwards direction, but also moving it to the right. When you reach the waistline draw a tight curve and complete the letter the same way you would finish the letter *i*.

The letter *m* is quite similar to the *n*—except that it has an extra downstroke. You should try to keep the same distance between the first, second and third downstrokes of this letter. To get a beautiful *m*, make sure that you branch in the same spot and keep the arches the same shape, and remember that all three downstrokes of the *m* are parallel to the slant line.

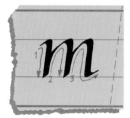

The *h* is a combination of the letters *l* and *n*. Start the *h* as if you were doing an *l* but when your pen reaches the base line, pierce the line, pause, and then continue as if you were writing an *n*. Try to keep your branching looking the same in all the letters in this group.

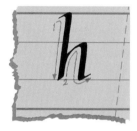

To letter the *b*, start out as if you were going to write an *h*. After you've branched and rounded the corner to draw the second downstroke, you'll need to bring your pen down parallel to the first stroke of the *b*, but when you get about two thirds of the way down (about 1 1/2 nib widths) bring your pen in towards the left and end the stroke on a thin line. Pick your pen up, put it at the bottom of the first stroke, and draw a gentle curving line to connect the two parts of the letter. (This is similar to the way you formed the bottom of the *j*.) You will get a more graceful connection if you also end this stroke on a thin line and overlap the two thin endings.

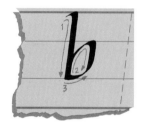

Like many letters, the *p* starts out like the letter *n*, but the first downstroke goes all the way to the descender line. Once there pick up your pen and place it at the base line, inside the stroke you've just made. Complete the letter the way you would finish a *b*. Try to make the bowls of the *b* and the *p* as similar as you can.

The letter **k** begins the way you'd start the letter **h**. After you branch, however, you'll want to make a more rounded stroke and then move the pen on a thin line until you connect back to the downstroke of the **k**—a little less than halfway up the x-height. Then move your pen back out one nib width along the thin line you've just

made, and bring it straight out at an angle until you reach the base line. Round the bottom of the stroke slightly, and end on a thin.

The letter **r** begins the way you'd start the **n**, but you'll need to branch four-fifths of the way up the downstroke instead of two thirds. When your nib hits the waist line, make a slightly rounded stroke, move the pen down and then right back up to end on a thin. The top of the **r** must be kept short so it does not interfere with spacing the letter after it.

Branching 2

This group of letters is quite similar to those in Branching 1, except that the branch occurs on the right side of the letter. You can practice these letters using exercise sheets 4A and 4B from the back of the book.

The letter **u** is an upside down **n**. It starts the same way you'd draw an **i** but instead of ending the **i** on a thin, glide up to the right about two nib widths over and one third of the way up the x-height. Then push the stroke straight up along the slant line until it just breaks the waist line. Pull the next stroke down on top of the stroke you've just done, and end like an **i**. To test whether you've done the **u** correctly turn your paper upside down. If it looks just like your **n**, give yourself a gold star! If not, try tracing an upside down **n** to get into the rhythm of drawing the **u**.

20

The letter *y* is a combination of the letters *u* and *j*. Start out like the *u* but instead of ending the second downstroke at the base line, bring your stroke all the way down until you reach the second nib width below the base line. Then you'll move the pen to the left at a 35° angle so that you end the stroke on a thin line at about the third nib width 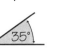 below the base line. Pick up the pen, move it to the left and line it up under the left hand side of the top part of the letter. Put the pen down just above the descender line and draw a gentle curving stroke that overlaps the thin line from the first stroke. The rounded part of this stroke should just hit the descender line.

The letter *a* is actually quite similar to the *u*—with a closed top. To start the *a*, put your pen just below the waistline, and moving down towards the left, draw a short, slightly rounded thin stroke. Bring the rest of the stroke down along the slant line, and continue as if you were making a *u*. When you reach the waistline, pick up your pen, go back to the starting point and put your pen down on the thin line. Overlap the thin line and continue gliding across the waistline until you connect to the other stroke, then pause. The top of the *a* is similar to, but a little straighter than, the top of the *f*. Next bring your pen down along the slant line and end like the *u*.

The letter *q* begins just like the *a*, but instead of ending the second downstroke at the base line bring it all the way down to the descender line and end it with the same serif you use on the *i*. Remember that the distance between the two downstrokes of the *q* should be the same as the distance between the two downstrokes of the *n*.

The letter *g* also starts just like the *a*, and it has the same ending as the *y*. Pay close attention to your counter space. The letters in this group have fairly flat, not round left hand sides, and should all be the same width.

21

The letter **d** combines parts of the **a** and the **l**. Start the same way you do the **a**. When you have completed the body shape, pick your pen up and draw an **l** that overlaps the thick part at the right side of the letter. The counter spaces of the letters in this group should all be the same shape.

Elliptical

All three letters in this group—the **o**, **c**, and **e**—are formed in two strokes and are the same width as the letter **n**. These letters are not round, but rather have an elliptical, or egg-like shape. The sides are fairly flat, which makes spacing this alphabet easier. To practice this group of letters, you'll need to use exercise sheet 5A.

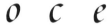

Start the letter **o** by placing your pen just below the waistline and pulling down and then around to the right in a gentle curve until you end on a hairline at about the first nib width. Then go back to the starting point and put your pen down to overlap the thin line. Head up until you reach the waistline, and continue gliding across and down until you connect to the other stroke. The sides of the **o** should be very similar to one another.

The letter **c** has the same first stroke as the letter **o**, but the bottom is a tiny bit more rounded, similar to the bottom of the **t**. The top of the **c** is made using the same stroke you would use on the top of the **f**. The right edge of the top and bottom of the **c** should line up along the slant line.

The letter **e** also has the same first stroke as the letter **c**, and its second stroke is reminiscent of the top part of the **k**. To write the **e**, start the second stroke as if you were doing an **o** but instead of bringing it down towards the base line make a rounded curve and move leftwards towards the middle of the letter. You should get a small thickening as you connect this stroke to the first stroke of your **e**.

Diagonal

Now that you've learned most of the alphabet you should be ready to meet the challenge of drawing this last group of letters—the *s*, *v*, *w*, *x*, and *z*. These are probably the most difficult to master, as none of the strokes are formed along the slant line. Instead, the slant line should bisect the letter. To write four of these letters (the *v*, *w*, *x*, and *z*) correctly you'll have the added challenge of changing your pen angle. To practice this group, use exercise sheets 6A and 6B.

S V W X Z

The letter *s* is made in three strokes— the first stroke which forms the middle of the letter is difficult to master. Start the *s* by putting your pen *below* the waistline and moving leftwards on a thin line, then curving to the right at a steep diagonal, and then moving left again to end on a thin *above* the base line. Pick up the pen and move it to just above the base line, about two pen widths to the left, so that it lines up with the left-most piece of the first stroke of the *s*. Draw a gentle curving stroke that overlaps the thin line from the first stroke.

The top of the *s* is the same as the top of the *c* or *f*. To draw the top of the *s*, put your pen back *on top* of the thin line that started the first stroke. Move the nib up to the

right so that your new stroke totally overlaps the first one. Continue moving to the right in a gentle curve and end just below the waistline. The main concern with the *s* is to make sure that it follows the same slant as the rest of the letters and is about the same width as an *n*.

To write the letter *v*, start by steepening your pen angle to 45°. The *v* begins with a serif similar to the one used on the *i*, but then you'll pull straight down at a diagonal. If you don't adjust your pen angle before doing this stroke, the stroke will be thicker than it should be. When you reach the base line, pause. Then push the pen upwards to the right (at about a 30° angle from the vertical axis). As you near the waist line, gently curve the stroke in towards the left and end on a thick. Double-check the width of your *v*, and make sure the thicks and thins match this exemplar.

The letter **w** is basically two letter **v**'s attached to each other. You'll need to change your pen angle to 45° for this letter, too. After almost completing the first **v**, instead of curving the stroke back to the left continue until you reach the waist line and then pull the pen down to form a second **v**. The upstrokes should be parallel to each other as should the downstrokes of this letter.

The letter **x** is written with two strokes. Like the **v** and the **w**, you'll need to steepen your pen angle to 45° before writing the first stroke of the **x**. It begins like the **v** but has a steeper angle as you head towards the base line. When the nib reaches the base line, gently curve upwards to end on a thin. Now comes the tricky part. Pick your pen up, *flatten* your pen angle to 25°, and put it at the waistline. Pull the stroke diagonally down to the left. As the pen approaches the base line, you should end the stroke by curving in a tiny bit towards the right, and having the bottom of the stroke pierce the base line. The two strokes of the **x** should cross slightly above the mid point of the letter so that the counter space triangle formed at the bottom will be a little larger than the one at the top of the letter.

The last letter of the alphabet, **z**, is written in three strokes. The first stroke is similar to the crossbar on the **t** and **f** but it starts on a thin line a little below the waist-line. Holding your pen at a 35° angle, move up to the waistline and then glide to the right about three nib widths. Pick your pen up and *flatten* the pen angle to approximately 15° before beginning the next stroke. Put the pen down so that the second stroke overlaps the first one, and pull down to the left at a sharp angle until you reach the base line. The bottom of the **z** should be just a little wider than the top of the **z**, so the second stroke will end slightly to the left of where the letter started. Before doing the third stroke, adjust your pen angle back to 35°. Put the pen down so that it overlaps the diagonal, and draw it straight along the base line until the bottom of the letter lines up with the top. You can end with a small hairline.

Improving Consistency

An abecedarian sentence, also known as a pangram, contains at least one of every letter of the alphabet. Abecedarian sentences are a great way to practice your letterforms. You can use any of these sentences, or invent your own. Before turning the page, do exercises 7A and 7B at the back of the book. Then check your letterforms against the diagrams on pages 26 and 27 to make sure you are avoiding some common problems.

1. The quick brown fox jumps over the lazy dog.

2. Calligraphers see words as exquisitely moving, subtle thicks and thins, zigzags and joins.

3. Calligraphy requires just a very few basics: pen, ink, dexterity, and most of all, zeal.

4. Five men, using just penknives, would cut the sixty quills needed by a dozen calligraphers.

5. Justly vexed, the queen exiled the calligrapher who spattered sumi ink on her fuzzy rug.

6. Sphinx of black quartz judge my vow.

7. Seven wildly panting fruit-flies gazed anxiously at the juicy bouncing kumquat.

8. Five boxing wizards jump extra quickly.

9. Pack my box with five dozen liquor jugs.

10. Traveling beneath the azure sky in our jolly ox cart, we often hit bumps quite hard.

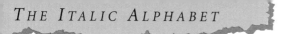

correct on left | incorrect on right

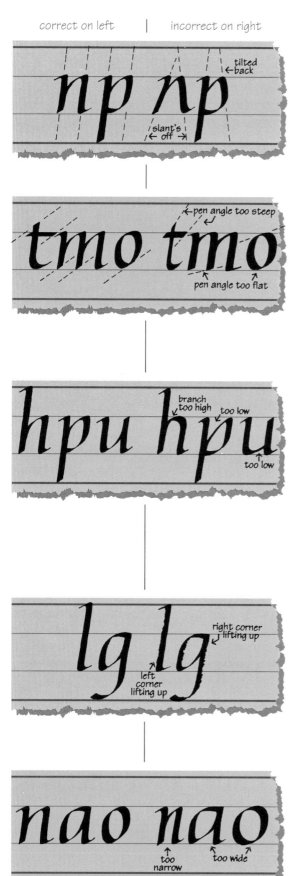

1. Slant

All vertical downstrokes should run parallel to one another. If you draw a ruled line through your downstrokes, are they all parallel to the 7° slant lines?

2. Pen Angle

If you are not holding your pen at the correct angle when making the lower case letters the weights of your strokes could be off. Are your lines thin in the right places? Are your lines thick in the right places?

3. Branches

Branches should grow out of the downstroke 2/3 of the way up/down the letter. Are you pushing the stroke up from the baseline and branching in the right place? It's a good sign if you have a white triangular space above /below the branch.

4. Letter Edges

Are both sides of your strokes clean and smooth? If your letters have ragged edges you might be pressing more on one side of the nib than the other, or lifting up one side of your pen.

5. Letter Widths

Almost all italic lower case letters are the same width as a properly branched *n*. Check yours. Are any too wide or too narrow?

6. Swashes

The top of the *f* and the bottom of the *j* and *g* should have gentle, graceful curves. Do your two strokes meet properly? Are the curves too round? Too flat?

7. Pen Scale

Are you making your x-height letters at five nib widths? Your ascenders and descenders at nine nib widths? If you are using your pen with the matching lining guide and filling the space between the lines the answer is yes!

8. Letter Shapes

These letters all have fairly straight sides which run parallel to the slant line. Are you making yours too round? If you're not sure, you can reread how these letters are formed and repeat the practice exercises.

9. Crossbars

The crossbar on the *t* and *f* should hang just below the waistline. Are yours in the right place? Are they too thick? Too thin? Check your pen angle to make sure it's at 35°.

10. Serifs

A properly shaped serif gives grace and elegance to your letterforms. Are yours too pointed? Too rounded? Too long? Too thick? Just right?

27

Italic Capitals

Now that you've learned the lower case letters it's time to focus on the upper case. In order to draw the capital letters, you'll need to hold your pen at a 25° angle instead of a 35° angle. Capitals are written at 7 nib widths. Like the lower case, they have a 7° slant.

ABCDEFGH IJKLMNOPQR STUVWXYZ

Before beginning the exercises you should trace over the letter shapes with a pencil to gain familiarity with their forms. This set of capitals uses a different, heavier serif called the "slab serif". A slab serif is a short stroke formed by placing the pen (*held at a 25° angle*) just under the cap line and moving it to the right one nib width. It resembles a very short cross bar. Try practicing this serif before starting the capital letterforms.

ABCDEFGH IJKLMNOPQR STUVWXYZ

Straight

This first group of capitals should be fairly easy to execute. After reading the descriptions of how to form the letter, use practice exercise sheets 8A and 8B to work on mastering their forms. The guidelines are designed for use with a smaller nib. Use either the *Elegant Writer®* extra-fine point or the *Panache®* medium nib to do these exercises.

I L F E H J T

To letter the *I*, start with your nib (**held at a 25° angle!!**) just below the cap line. Draw a slab serif by moving your pen to the right one nib width, and then move your pen down along the slant line until you reach the base line. End your stroke on a thick— with the tip of the nib just breaking through the base line. Many italic capitals are based on the *I*, so it would be a good idea to master it before practing the other letters.

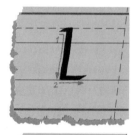

Begin the *L* as if you were writing an *I*, and pause at the bottom. For the second stroke move it horizontally across the base line. The bottom of the L should be fairly narrow— between 1/2 and 3/5 the length of the *L*'s downstroke.

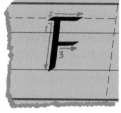

The letter *F* also begins like the *I*. For the second stroke, put your pen back where you started the first stroke, and move it horizontally just under the cap line. Again, be sure not to make this stroke too wide— no more than 1/2 to 3/5 the length of the downstroke. End the stroke on a thick. Pick up your pen and put it inside the downstroke at a hair below the halfway mark and draw another horizontal stroke, paralleling the top of the *F*. This last stroke should be the same length as the top one, and will also end on a thick.

The letter *E* is a combination of the letters *L* and *F*. Start by making an *L*, and add the two horizontal strokes of the *F*. The middle crossbar of the *E* is placed at the halfway mark, so that the top and bottom counters are the same size. Make sure that all three horizontal strokes are the same length. Your *E* should be approximately twice as tall as it is wide.

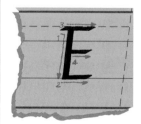

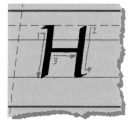

The letter *H* begins like the *I*. After completing the first stroke, move your pen over approximately 4 nib widths to the right and place it at the cap line. Bring the stroke down along the slant line, and end with a hairline serif at the base line. The cross bar is a short horizontal stroke which connects the two downstrokes. It is placed slightly above the halfway point of the letter.

The *J* has the distinction of being both a very narrow letter and one of the few capital descenders. It begins like the letter *I*, and ends with the same shape bottom stroke you used on the lower case *j*. The capital *J* descends to 2 nib widths below the base line.

The letter *T* starts with a stroke made straight down along the slant line. Begin the next stroke by putting your pen 2 to 2 1/2 nib widths to the left of the downstroke, and moving it straight across, just below the cap line. The cross bar should be 4 1/2 to 5 nib widths wide.

Bowl

These letters all combine curved and straight strokes. Use practice exercise 9A to work on their shapes.

P B R D U

The letter *P* begins like the *I* and is made in three strokes. For the second stroke, place your pen back where you started the first stroke and move it horizontally two nib widths to the right. Then pull down and around in a curve that will end on a thin line about 3 1/2 nib widths high. The last stroke starts in the middle of the downstroke of the *P* and is the same one you'd use on the bottom of a *g*. It connects with and overlaps the thin stroke at the end of the second stroke.

30

The letter **B** is similar in many ways to the **P**, and is drawn with 4 strokes. Start like the **L** but make the second stroke quite short, and end it on a thin line. The next stroke is the same as the one you make for the bowl of the **P**. The last stroke is a second bowl stroke which connects strokes 3 and 2. The letter **B** is not a wide letter, but the bottom bowl should be a little larger than the top bowl.

The letter **R** starts out like the letter **P**, but the second stroke touches the first stroke at the midpoint. Start the third stroke where the second stroke ends, and move your pen down on a diagonal until you reach the base line, then end on a thin. The end of the last stroke should be one nib width to the right of the widest part of the bowl.

The letter **D** starts like the **B**, but the second stroke is a bit longer. The third stroke forms a round bowl connecting the first and second strokes. Be sure to keep the right side of your **D** round.

The **U** is formed in two strokes. Start with a slab serif and then move your pen straight down along the slant line until the second nib width where you should begin curving the stroke over to the right. This stroke should end on a thin. The second stroke of the **U** starts back at the cap line, and comes straight down along the slant line, touches the first stroke's thin end and continues until the base line, where it ends with a hairline serif like the one used on the lower case *l*.

Round

The four letters in this family group are all quite round, and are approximately as wide as they are high. Practice exercise sheet 10A will help you work on perfecting these letters.

O Q C G

Start the letter *O* by placing your pen just below the cap line and pulling down and then around in a wide curve until you end on a hairline at about the first nib width. Then go back to the starting point and put your pen down to overlap the thin line. Head up until you reach the cap line, and continue gliding across and down until you connect to the first stroke. The *O* is a round letter whose sides should be very similar to one another.

Start the *Q* the same way you'd write an *O*. When the *O* shape is completed, put your pen one nib width above the base line just inside the *Q*. Move your pen up on a thin, then diagonally down until the stroke crosses over the thinnest part of the letter. End the stroke with a hairline serif at one nib width below the base line.

The letter *C* has the same first stroke as the *O*. To draw the top of the *C*, put your pen back *on top* of the thin line that started the first stroke. Move the nib up to the right so that your new stroke totally overlaps the first one. Continue moving to the right in a gentle curve, and just below the cap line complete the stroke by bringing it back towards the left to end on a very short thin stroke.

Begin the *G* as if you were writing a *C*. When the *C* shape is completed, put your nib at the halfway mark (3 1/2 nib widths) and draw a slab serif. Continue the stroke by bringing it straight along the slant line until it connects with the end of the first stroke.

Diagonal

This group of letters is the most difficult to master because most of them require changing your pen angle at least once while you are drawing the letterforms. They are additionally challenging because most of the strokes are not formed along the 7° slant line. Instead, the slant line should bisect the letter. To practice this group, use exercises sheets 11A and 11B.

S K N M A V W X Y Z

The capital *S* is made just like the lower case *s*, only larger. Start by putting your pen *below* the cap line and moving leftward on a thin line, then curving to the right at a steep diagonal, and then moving left again to end on a thin *above* the base line. Pick up the pen and move it to just above the base line, about four nib widths to the left, so that it lines up with the left-most piece of the first stroke of the *S*. Draw a gentle curving stroke that overlaps the thin line from the first stroke. The top of the *S* is the same as the top of the *C*. Draw it by putting your pen back *on top* of the thin line that started the first stroke, and moving the nib up to the right so that your new stroke totally overlaps the first one. Continue moving to the right in a gentle curve and end just below the cap line. The *S* is almost twice as tall as it is wide. Make sure that it visually follows the same slant as the rest of the letters.

Start the letter *K* the same way you'd start an *I*. Then pick your pen up, *flatten* the pen angle to 15° and put it on the cap line about four nib widths to the right of the first stroke. Pull the second stroke straight on a diagonal towards the middle of the first stroke until it touches. The second stroke should touch the first stroke slightly above the halfway point. Then move your pen diagonally to the right until you reach the base line and end on a thin. The end of the last stroke should be one nib width to the right of the top of the *K*.

In order to get the right thickness for the down-strokes of the *N*, you'll have to steepen the pen angle to 55°. To do the first stroke, simply hold your pen at a 55° angle and pull straight down along the slant line. Then move your pen back to the cap line, flatten your pen angle to 25° and draw a slab serif on top of your first stroke. Continue the second stroke by pulling diagonally towards the base line. Next pick your pen up, steepen the angle to 55° again, and put it back at the cap line. Pull the third stroke down along the slant line until it overlaps the bottom of the second stroke. Make sure the first and third strokes are thinner than the diagonal stroke. Like the *H*, the *N* should be two thirds as wide as it is high.

The letter *M* is a wide letter made in 4 strokes. Look closely at the exemplar before drawing this letter, and notice that the sides of the *M* are slightly splayed. Start the *M* with a slab serif, holding the pen at a 25° angle. Then steepen your pen angle to 55°, and bring the stroke straight down *at a 10° slant* instead of the usual 7° slant. Keeping the 55° angle, put your pen back at the cap line, inside the stroke you've just drawn, and draw a straight diagonal stroke downward until you hit the base line, about 3 nib widths to the right of the first stroke. For the third stroke you'll have to flatten your pen angle to 35°, and put it on the cap line about six nib widths to the right of the first stroke. Pull down at a diagonal until you connect with the second stroke at the base line. The center of your *M* should look

like a wide *V*. To do the last stroke you'll have to flatten your pen angle even more— back to 25°, and pull straight down *at a -3° slant.* To make sure your *M* is properly proportioned, check that it is at least as wide as it is high, and that the two vertical strokes meet the diagonal strokes at the same height. (**Hint**: check the two triangular counter spaces formed by the downstrokes— the tops of the white triangles should both be at the same height— around 5 1/2 nib widths.)

The letter *A* also requires several pen angle changes. You'll begin by doing a slab serif with the pen held at a 25° angle. Pause, and steepen your angle to 35°. Draw the stroke diagonally down towards the left until it just pierces the base line. Pick up your pen and steepen the angle to 45°. Put it back at the cap line overlapping your first stroke, and draw it diagonally down towards the right and end on a thin. At the base line the two downstrokes of the *A* should be the same distance apart as the two downstrokes of the *N* or the *H*. The crossbar is made by *flattening* your pen angle to 25° and drawing a stroke which connects the two downstrokes just below the halfway point.

To write the letter *V*, start by steepening your pen angle to 45°. The *V* begins with a hairline serif similar to the one used on the *i*, but then you'll draw a straight diagonal stroke downward to the right until you reach the base line. Then pick up your pen, *flatten* the pen angle to 35° and place it at the cap line about 4 nib widths to the right of the first stroke. Draw a straight diagonal stroke downward until you overlap your first stroke. Double-check the width of your *V*, and make sure the thicks and thins match this exemplar.

The *W* is basically two slightly narrow letter *V*'s attached in the middle. Hold the pen angle at 45° for the first and third strokes of the *W*, and at 35° for the second and fourth strokes. The *W* is a wide letter— at least as wide as it is high. Check to make sure that your weights match the exemplar and that the upstrokes (and downstrokes) parallel one another.

Like the *V* and the *W*, you'll need to steepen your pen angle to 45° before writing the first stroke of the *X*. It begins like the *V* but has a slightly shallower angle as you head towards the base line. When the nib reaches the base line, gently curve upwards to end on a thin. To do the second stroke, *flatten* your pen angle to 25° and put it at the cap line about four nib widths to the right of your first stroke. Bring the stroke straight down to the left on a diagonal. As the pen approaches the base line, you should end the

stroke by curving in a tiny bit towards the right, and having the bottom of the stroke pierce the base line. The two strokes of the *X* should cross slightly above the mid point of the letter so that the triangular counter space formed at the bottom will be a little larger than the one at the top of the letter. The *X* should be the same width as the *N*.

The letter *Y* is formed in three strokes. It resembles a mini *V* placed on top of the bottom half of an *I*. Like the *V*, you'll begin by holding your pen at a 45° angle, starting out with a small hairline serif and then drawing a straight diagonal stroke downward until the third nib width. Then pick up your pen, *flatten* the pen angle to 35° and place it at the cap line about 4 nib widths to the right of the first stroke. Draw a straight diagonal stroke downward until you overlap your first stroke. The third stroke overlaps the connection point of the first two strokes, and is pulled straight down along the slant line until it just pierces the base line.

The capital *Z*, just like the lower case one, is written in three strokes. The first stroke is similar to the crossbar on the *T* but it starts on a thin line a little below the cap line. Move your pen up to the cap line and then glide to the right about four nib widths. Pick your pen up and *flatten* the pen angle to approximately 15° before beginning the next stroke. Put the pen down so that the second stroke will overlap the first one, and move down to the left at a sharp diagonal until you reach the base line. The bottom of the *Z* should be just a little wider than the top, so that the second stroke will end slightly to the left of where the letter started. Before doing the third stroke, adjust your pen angle back to 25°. Put the pen down so that it overlaps the diagonal, and draw it straight along the base line until the bottom of the letter lines up with the top, and end with a small hairline.

Numbers

Like the letters of the italic alphabet, italic numerals are slanted 7°. Numbers are written at the same height as the capitals— 7 nib widths— with the pen held at a 25° angle. Study the ductus and shape of the numbers carefully, and practice their forms before beginning the project section.

Punctuation

Punctuation marks are graphic devices which mark pauses or stopping points in a text. Note where each mark is placed in relation to the letters— none are above the cap line. Remember to hold your pen at a 35° angle when making these symbols, and to slant them 7°. It's easy to be a little sloppy when making very small marks—try to keep your punctuation marks crisp and clear.

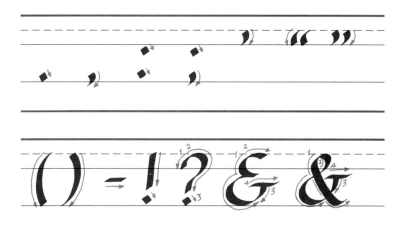

Italic Variations

Now that you've learned the italic alphabet, it's important to continue practicing and studying good letterforms. As your calligraphic skills improve, you'll find that it is possible to change the feel of your italic by varying the pen angle, pen scale, branching and slant of the letters. You can also embellish your letters by adding swashes and flourishes like the ones in this section.

A B C D E
F G H I J K L M
N O P Q R S T U
V W X Y Z

These two sets of swash capitals can be used to enhance a design, but do not use these more decorative forms to write entire words. Aim for consistency with your swashes, embellishments and flourishes.

A B C D E
F G H I J K L M
N O P Q R S T U
V W X Y Z

The examples on these two pages show letter-forms that are challenging for a beginner to master but that advanced calligraphers do with ease. As you gain confidence in your lettering, don't be afraid to experiment by copying these alternate letterforms or other italic alphabet variations that inspire your creativity.

Some of these letters were made by changing the pen angle inside a stroke, or by writing with the corner of the pen. If you want to flourish some of your letterforms, be sure to do it sparingly—usually at the top or bottom of a page so the flourishes won't interfere with the other letters. Remember, sometimes less is more— when in doubt, leave it out!

Spacing

There are three types of spacing that you need to consider— letter, word and line spacing. Proper spacing can help make poor letterforms look better, but bad spacing will make even good letterforms appear awkward. Spacing is not something you can measure mechanically with a ruler; the best way to judge it is by eye. Here are some guidelines that will help you learn how to properly space your calligraphy.

LETTER SPACING — When spacing letters, the goal is to have the same amount of space between each letter as you do between the downstrokes of your *n*. If you write the word "minimum" (or any other word that has only straight, not curved downstrokes) you should be able to cover the tops and bottoms of the letters and wind up with a row of evenly spaced strokes. Some calligraphers refer to this as the "picket fence" technique. If you are having trouble spacing your straight letters evenly, try the following exercise. Draw 15 equidistant lines (at a 7° slant) and write the word "minimum" on top of them. This will help you to space (and branch!) the letters evenly. Then, without drawing lines, write the word again until you feel comfortable maintaining the proper letter spaces.

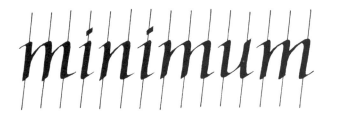

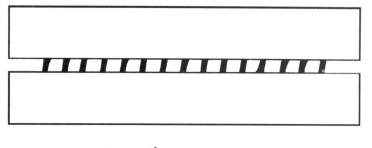

spacing too tight spacing too wide

40

While it is fairly easy to space straight lines evenly, it is trickier to space a straight letter next to a curved letter, or two curved letters next to each other. Visually, the amount of space between letters should be the same, even if the shapes of the spaces are different. Imagine pouring water into the spaces between letters as though they were different shaped containers; each space should hold the same amount of water. In order to make these spaces visually equal, you'll have to put two curved letters closer together than two straight letters. A curved letter and a straight letter will be spaced at an in-between point—closer than two straight letters but not as close as two curved letters.

Look at the counter space formed by these letter combinations and you'll see that while the three shapes are different, the volume of space they take up is the same.

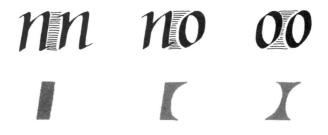

To check your spacing, try writing a line of words in black ink, and then filling in the spaces between the letters in a different color. If the colored areas are all similar in size (although they won't all be the same shape), your letter spacing is right on target! Another good method for checking your spacing is to turn your page upside down. This helps you to stop reading letters and concentrate on looking at the strokes and counter spaces. Any "dark spots" you see may come from letters placed too close together.

There are some letter combinations that are particularly difficult to space evenly. Letters with open counters (like *c*, *r* and *s*) and diagonal letters (like *v* and *w*) need to be spaced closer to the next letter. The following examples should help guide you. The + shows too much space and the - shows where there is not enough space between the letters.

incorrect	correct	incorrect	correct
lifts	lifts	chose	chose
twin	twin	carry	carry
gravy	gravy	cover	cover
extra	extra	artist	artist
rinses	rinses	koala	koala
actors	actors	flax	flax
every	every	purse	purse
hilly	hilly	zebra	zebra

WORD SPACING — An inter-word space should be slightly wider than a letter space. If you leave too much space between words your page will have rivers of white flowing through it. If you leave too little space between words the text will be difficult to read. A good rule is to be able to fit a properly spaced letter *i* between your words.

If a word starts or ends with a letter that has an open counter (like *c* or *r*) you'll need to adjust the spacing by bringing the words just a little closer together.

word space too close *word space too far*

word i space i just i right *word space just right*

LINE SPACING — Interlinear spacing, or spacing between lines of writing, affects the look of the whole page. It can be adjusted to create different textures and effects. For instance, wide interlinear spacing can add a sense of airiness and delicacy to a page. Wide spacing is usually preferred for formal, traditional pieces, while tight spacing can give a page a contemporary appearance. The length of your lines should also be taken into consideration when planning your layout. In terms of readability, long lines of text require more interlinear space than short lines.

One problem that many beginning calligraphers encounter is having their ascending and descending letters collide. Generally a distance of twice the x-height (10 nib widths) between lines of writing will guarantee that your ascending and descending letters won't touch.

Interlinear spacing examples:

Calligraphy, the art of beautiful lettering, is something anybody can learn with sufficient patience and practice.

5 nib widths

Calligraphy, the art of beautiful lettering, is something anybody can learn with sufficient patience and practice.

10 nib widths

Calligraphy, the art of beautiful lettering, is something anybody can learn with sufficient patience and practice.

15 nib widths

Calligraphy, the art of beautiful lettering, is something anybody can learn with sufficient patience and practice.

20 nib widths

43

Layout & Design

Layout is the foundation or framework of every lettering job. A well designed layout is just as important as the lettering and spacing. When planning a layout, the first step is to decide what it should contain. If you are doing a sign or poster, start by listing all the subject matter in order of importance. Think about the five W's— who, what, where, when and why. Prioritizing this information will help determine which should appear most prominently, and which should follow as support material.

If you are working on a layout for a flyer about an upcoming play, the priority list might contain: title, star, theater group, location, time and cost. After selecting the dominant feature, divide the remaining copy items into groups which will be lettered in a smaller size than the main copy.

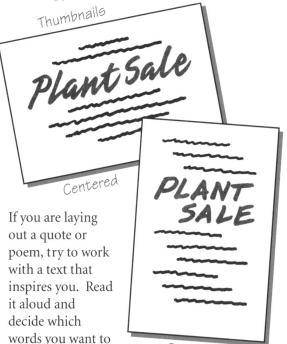

Thumbnails

Centered

Staggered

If you are laying out a quote or poem, try to work with a text that inspires you. Read it aloud and decide which words you want to emphasize in the composition. Many calligraphers think of themselves as interpretive vehicles for an author's words, and try to have their layout reflect the mood (i.e. upbeat, passionate, sad) of the text.

Whatever you choose to letter, the next step is to make some quick thumbnail sketches of the way

you want to lay out your text on the page. If you use a soft pencil (2B) to show the relative size and weight of each line, you'll be able to get a good idea of what the layout will look like without having to write all the words.

There are several different kinds of layouts that you might want to try. These include centered, staggered, flush left, flush right and asymmetric. Thumbnails are a great opportunity to experiment and be creative.

Flush Left

Once you have completed your thumbnails, select the most pleasing and effective design and create a "finished rough". This is a marker or inked version done in the same

PLANT SALE

Flush Right

Plant Sale

size in which you want to do the final artwork. By doing this you can make sure that all the words fit

Plant Sale

Asymmetric

where you planned and that your pen and guidelines are the right size for the piece. You might need to make adjustments before doing the final lettering. Many calligraphers will also photocopy their roughs, cut the lines apart and re-lay them out if necessary. If you are working on a piece that will be reproduced, read about how to do a mechanical on pages 56 and 57.

You may want to enhance your layout by using color to add contrast to the composition. While color will not help a piece that is poorly laid out and lettered, it can add interest and attract attention to a good design. Keep your color combinations simple (don't use more than three different colors in one piece) and well thought out.

Margins

Margin widths are an important element to consider when designing your piece. Leave plenty of margin room or white space around the lettering. This will prevent the design from having a cluttered or crowded appearance.

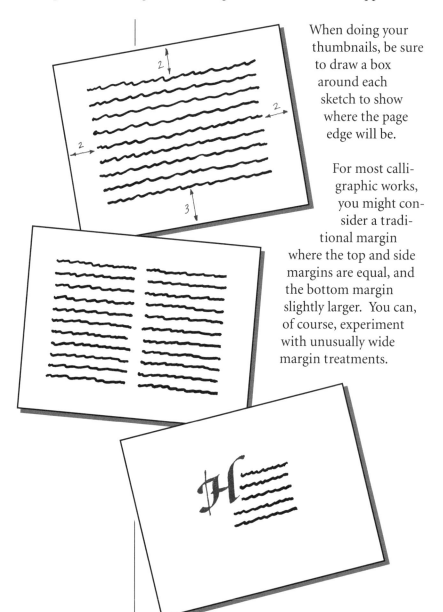

When doing your thumbnails, be sure to draw a box around each sketch to show where the page edge will be.

For most calligraphic works, you might consider a traditional margin where the top and side margins are equal, and the bottom margin slightly larger. You can, of course, experiment with unusually wide margin treatments.

Contrast

Contrast is important to achieving a visually interesting composition. You can create great contrast by changing the size, weight, color and/or position of the text.

For contrast in size, use a larger pen to letter the words you want to stand out. If you write these words using an x-height of 3 or 4 nib widths the letters will be bolder than those written at 5 nib widths. By lettering the featured words in a bright, eye-catching color, they will stand out from the rest of your text. Allowing extra white space around the words you want to emphasize or placing them at an angle will also help to focus a reader's attention on them.

You can combine any of these elements— have your featured words written both larger and in red, or at an angle using a heavier weight. Most importantly, remember to keep your piece simple and have *one* feature dominate the layout.

Envelopes

Now that you are familiar with the italic alphabet, it's time to begin using your calligraphy on various projects. The first job that many calligraphers tackle is addressing envelopes. A hand lettered envelope can set just the right tone for a special event or party. You can address envelopes in a traditional, formal manner or in a more creative way. Formal envelopes are usually written in black ink and are used for weddings and other formal occasions. Creative envelopes are used to address personal correspondence, such as letters, greeting cards, and invitations to informal parties.

Abbreviations are not used when addressing envelopes to a formal affair, except for titles (Mr., Mrs., Jr., etc.). Ms. is not an abbreviation, but most people customarily put a period after it, to be in keeping with the other titles. Street names, cities and states should all be written out. Numbered streets (Sixth Avenue) should be spelled out up until the number nineteen.

Whether you are addressing envelopes for yourself or doing them for a friend, family member or client, you should be familiar with the etiquette of envelope addressing. Since a wedding is the most common occasion for sending a formal envelope, let's discuss the specifics of addressing wedding invitations. An invitation to a wedding is traditionally mailed in two envelopes. The name and address of the recipient is placed on the lower part of the outer envelope. The sender's return address (but not their name!) is written, printed or embossed on the back flap of the outer envelope. The inner envelope, which houses the invitation and any accompanying cards, has no glue on the flap. Only the recipient's surname and title appear on the inner envelope. The inner envelope is placed into the outer envelope with its back flap facing the front of the outer envelope. This way the recipient will be able to read the names on the inner envelope as soon as they pull it out. Wedding invitations should be mailed six weeks before the event.

Here are the proper forms of address to use in social situations.

Married couple:
outside: Mr. and Mrs. Richard Piper
inside: Mr. and Mrs. Piper

Married couple with young children:
outside: Mr. and Mrs. Richard Piper
inside: Mr. and Mrs. Piper
Steven and Elizabeth

Married couple with children 13 to 18:

outside:	Mr. and Mrs. Richard Piper
inside:	Mr. and Mrs. Piper
	Master Steven Piper
	Miss Elizabeth Piper

Children over 18 should receive a separate invitation.

Married couple with different surnames:

outside:	Ms. Jennifer Lawson and
	Mr. Richard Piper
inside:	Ms. Lawson and Mr. Piper

Married couple, woman is a doctor:

outside:	Mr. and Mrs. Richard Piper
inside:	Mr. and Mrs. Piper
	or
outside:	Dr. Jennifer Piper
	and Mr. Richard Piper
inside:	Dr. Piper and Mr. Piper

A woman customarily loses her professional title in a social situation; however, if you know her title is important to her, she would be addressed first.

Married couple who are both doctors:

outside:	Drs. Richard and Jennifer Piper
inside:	Drs. Piper

Single woman:

outside:	Miss (or Ms.) Jennifer Lawson
inside:	Miss (or Ms.) Lawson

Single man:

outside:	Mr. Richard Piper
inside:	Mr. Piper

Single woman with guest:

outside:	Miss (or Ms.) Jennifer Lawson
inside:	Miss Lawson and Escort
	(or Miss Lawson and Guest)

Traditionally women have been escorted, and men have brought guests; however, current etiquette permits women to bring a guest instead of an escort.

Single man with guest:

outside:	Mr. Richard Piper
inside:	Mr. Piper and Guest

Divorced woman:

outside:	Mrs. (or Ms.) Jennifer Piper
inside:	Mrs. (or Ms.) Piper

When inviting a person who will be bringing a guest, it's proper to send the guest his or her own invitation.

Widow:

outside:	Mrs. Richard Piper
inside:	Mrs. Piper

Unmarried couple living together:

outside:	Ms. Jennifer Lawson
	Mr. Richard Piper
inside:	Ms. Lawson
	Mr. Piper

Formal Envelopes

The three formats for addressing a formal invitation are to have the address flush left, centered or staggered. Centering an address is a lot more work so most calligraphers prefer to have the lines either flush left or staggered.

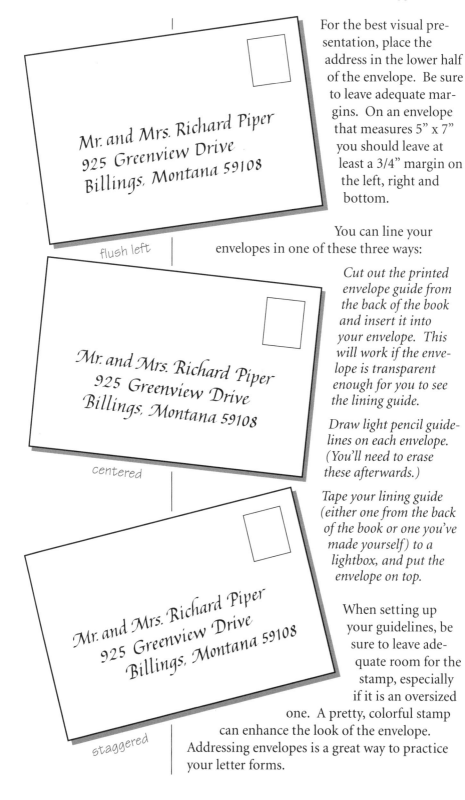

Mr. and Mrs. Richard Piper
925 Greenview Drive
Billings, Montana 59108

flush left

Mr. and Mrs. Richard Piper
925 Greenview Drive
Billings, Montana 59108

centered

Mr. and Mrs. Richard Piper
925 Greenview Drive
Billings, Montana 59108

staggered

For the best visual presentation, place the address in the lower half of the envelope. Be sure to leave adequate margins. On an envelope that measures 5" x 7" you should leave at least a 3/4" margin on the left, right and bottom.

You can line your envelopes in one of these three ways:

Cut out the printed envelope guide from the back of the book and insert it into your envelope. This will work if the envelope is transparent enough for you to see the lining guide.

Draw light pencil guidelines on each envelope. (You'll need to erase these afterwards.)

Tape your lining guide (either one from the back of the book or one you've made yourself) to a lightbox, and put the envelope on top.

When setting up your guidelines, be sure to leave adequate room for the stamp, especially if it is an oversized one. A pretty, colorful stamp can enhance the look of the envelope. Addressing envelopes is a great way to practice your letter forms.

Creative Envelopes

Everyone loves to see their name "in lights". Creatively addressing envelopes to friends and family members is a great way to let them "shine".

Try contrasting a name written using a large nib with an address written with a smaller nib. You can also combine calligraphy with your own handwriting, or with simple mono-line caps. To line a creative envelope, draw lines lightly in pencil directly on the envelope. You can use a flexible rule to get unusual shapes or wavy lines.

· 345 Eden Trail ·
JOANNE FINK
·Lake Mary, Florida 32746 ·

Experiment with different colors, or working on a colored envelope. Write the name in one color and the address in another color. If you write the name in a light color (pink or orange) you can try shadowing or outlining the letter shapes with a thin, dark colored marker to make them stand out.

cheryl Adams
2124 Northwest 139th Street
Des Moines, Iowa · 50325

Creative envelopes are a great way to practice new techniques and ideas. The recipient is sure to enjoy your design, and you'll have fun creating miniature works of art.

·JOANNE·FINK·
345
Eden Trail
Lake Mary, Florida 32746

The thumbnails on pages 52 and 53 will give you some additional creative envelope layout ideas. Try some of these designs, or come up with your own. Most importantly, have fun!

Creative Envelope Layouts

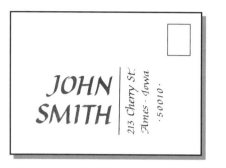

Horizontal & Sideways

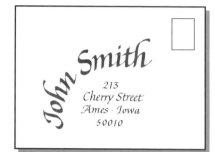

Curved & Horizontal

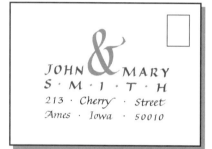

Two Names with Ampersand

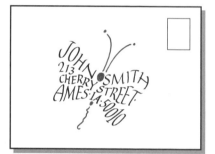

In a Shape

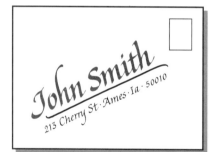

Diagonal with One Line Address

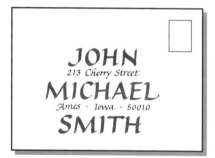

Alternate Name & Address

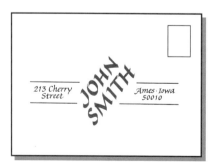

Split: Diagonal & Horizontal

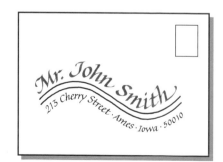

Wavy

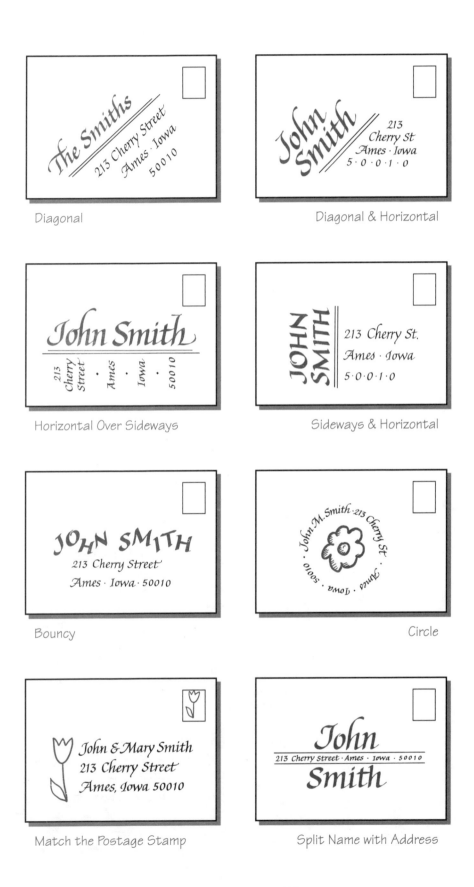

Diagonal

Diagonal & Horizontal

Horizontal Over Sideways

Sideways & Horizontal

Bouncy

Circle

Match the Postage Stamp

Split Name with Address

Invitations

Usually when hosting a party you'll be inviting more than one guest, and therefore want more than one copy of the invitation. When multiple invitations are needed it's fastest and easiest to design an original and then photocopy it or take it to your local printer to be reproduced.

Designing for reproduction has many advantages. First of all, you'll be able to work with a larger nib, which will help you do better writing. When you complete the invitation design, you can reduce it so it fits proportionately on your page. Reducing lettering hides some of the flaws (like ragged edges) and makes your piece look more professional.

Another advantage to reproducing your calligraphy is that you won't have to letter the entire invitation perfectly in one shot. Instead, you can do each line as many times as you want until you are satisfied. You can even touch up your letters with white and/or black paint and a fine brush. Once you are happy with every line you can paste them together using the method shown on pages 56 and 57. This is called making a "paste-up" or "mechanical" of your artwork.

Although you'll be working with black ink on white paper, the printer will be able to reproduce your design in any color ink, on any color paper stock you request. You can even have your invitation printed on pretty stationery or inside a bordered card, as you can see from the example on page 57.

On pages 56 and 57 you'll learn how to design an invitation with a centered layout for reproduction. In addition to your calligraphy pens with black ink, you'll need to have the following supplies handy for this project: paper (19 lb layout bond is a good choice), your lining guides, scissors or an X-acto knife with a sharp blade, a ruler, a pencil and eraser (or a non-repro blue pencil, which won't need to be erased), removable tape and graph paper with non-reproducing blue lines.

Formal Invitation

Mr. and Mrs. Russell E. Sargent
request the pleasure of your company
at the marriage of their daughter

Catherine Anne
to
Mr. Jonathan Peterson

Saturday, the twenty-fifth of October
Nineteen hundred ninety-six
at six o'clock in the evening
Westport Valley Country Club
Huntington, New York

• Formal invitations
usually feature a
centered layout.

We invite you

to share in our happiness

when our daughter

Cathy Sargent
marries
John Peterson

on Saturday, October 25th
at six o'clock
Westport Valley Country Club
in Huntington, New York

• Informal invitations
can have a more
creative layout and
often include a
decorative border or
design treatment.

Informal Invitation

The following steps will teach
you how to paste up a mechanical.

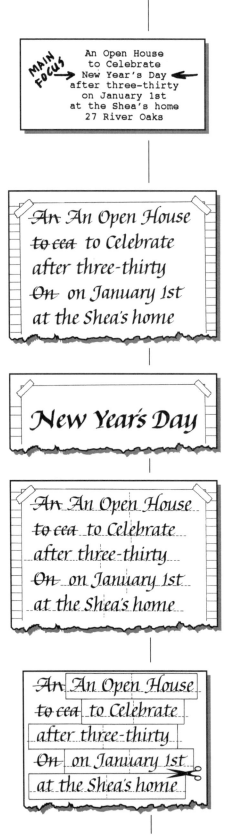

STEP 1

Read the text of the invitation to
decide which words are the most
important and should be empha-
sized. For an effective layout it's a
good idea to have the important
words larger than the rest of the text.

STEP 2

Using a medium or small-sized nib
(with matching guidelines taped
behind your writing sheet), write out
all the lines of the invitation except
the words that you want to empha-
size. Since this is for reproduction,
you can write the same line as many
times as you want until you are satis-
fied with the way it looks.

STEP 3

Using your broad nib and matching
guidelines, write the words that you
want to stand out in the invitation.

STEP 4

Measure each line that you want to
use. Mark the center point of each
line using your non-repro blue pen-
cil. Some calligraphers like to use a
centering ruler to do this. Before
removing your guidelines take your
ruler and lightly trace the base lines
onto your sheet.

STEP 5

Cut out the lines with a scissors or
an X-acto knife and metal-edged
ruler. You'll want to cut fairly close
to the tops and bottoms of the letters,
but leave a little bit of extra paper
at the sides. In order to avoid smear-
ing, try not to touch the letters with
your fingers.

56

STEP 6

Using your non-repro blue pencil, draw a vertical line down the center of your piece of graph paper. Decide how far apart you want your lines of lettering to be (you can adjust this later if necessary), and mark that distance on the side of the page. Remember to leave extra space for the lettering you did with your larger nib.

STEP 7

Take each strip of calligraphy and line up the base line and center mark with the lines on your graph paper. Tape them in place with removable tape. Sometimes it's difficult to tell if you have all the strips centered and straight because the cut marks are distracting. If possible, photocopy the invitation to see how it looks. A good way to check the centering is to fold the photocopy in half— if all the lines meet, you've done a great job! At this point some calligraphers prefer to adhere the strips to the graph paper more permanently by using a glue stick, spray mount, waxer or rubber cement. If you used a regular pencil instead of a non-repro blue pencil be sure to erase all pencil lines.

STEP 8

Take your mechanical to a copy shop and have the printer show you a reduced photocopy of what the lettering will look like on your invitation. You may bring your own (bordered) paper to the printer, or ask what different papers and envelopes are available. If this is your first experience printing something, try to get estimates from a couple of different places and ask to see samples of their work.

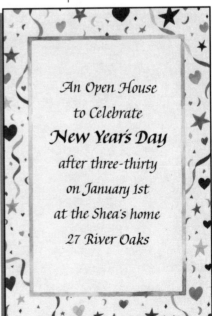

Greeting Cards

Everyone enjoys receiving a greeting card— it tells the recipient that he or she is being remembered by someone who cares. But a personalized card, with the recipient's name written in beautiful calligraphy, is something most people will treasure forever.

One-of-a-kind greeting cards, created with a specific recipient in mind, are fun to design. A personalized card usually mentions a name as well as an occasion: "Happy Anniversary Maura and Stu", or "Happy 27th Birthday Debby!". Colorful lettering, or a pen pattern border (like the ones shown on page 13) can enhance a design. Rubber-stamped decorations, stickers or illustrations can make a personalized greeting card a small work of art.

There are two types of greeting cards: "Seasonal cards", which are sent for Christmas, Valentine's Day and other holidays, and "Everyday cards". An Everyday card is one that can be sent on any day of the year. The "everyday category" is divided into two types: occasion and non-occasion. An occasion is an event, like a birthday, illness or marriage, that prompts someone to send a card. A non-occasion card usually falls under the headings of friendship, thinking of you or romantic love. Non-occasion cards are most often sent for no particular reason other than to let the recipient know they are being thought about.

Designing greeting cards for your friends and family is a great way to practice your calligraphy and layout

58

techniques. You can also have fun experimenting with different paper folding methods, or making an envelope out of the same paper you chose for your design. You can try decorating the edge of your card with lace or adding a three dimensional touch such as dried flowers or a small bow. Mounting your design on a sheet of colored or marbled paper is a great way to get a nice border. You can also cut your card into a shape (like a heart) that will complement its message. Let your imagination soar— the possibilities are endless!

In addition to creating personalized cards, you may want to design a Season's Greetings card that you can print multiple copies of to send out at the holidays this year. It's a perfect opportunity to show off your new calligraphic skills.

For information on how to design a piece for reproduction, reread the invitation section beginning on page 54. You can personalize a printed card by adding a name, a dot of red paint, a watercolor flower, a bit of gold glitter, a ribbon or a rubber-stamped image to the design.

Let these examples and the sample greeting card layouts on page 60 inspire you to create your own wonderful designs.

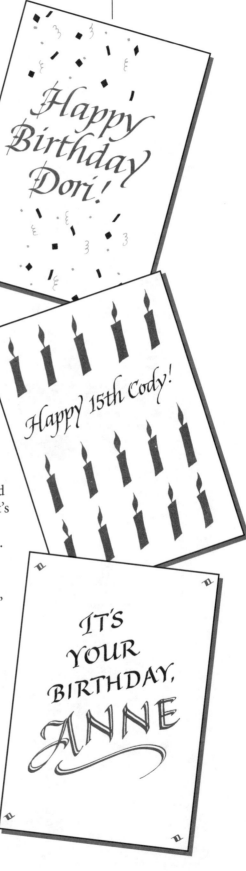

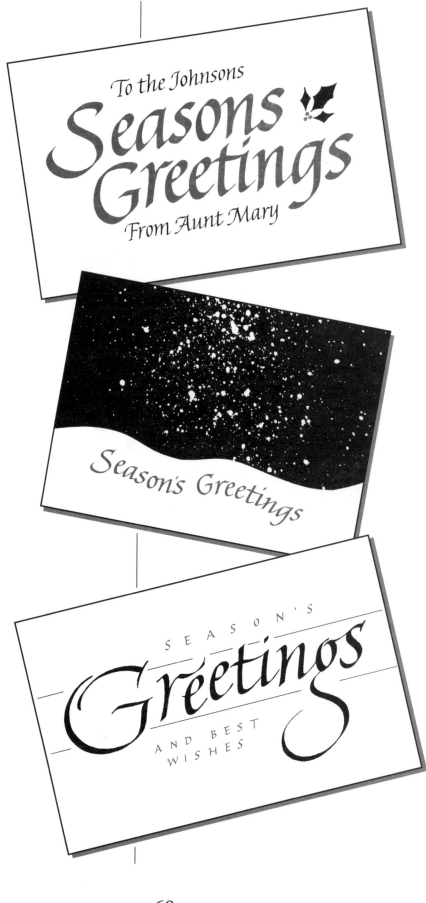

To the Johnsons
Seasons Greetings
From Aunt Mary

Season's Greetings

SEASON'S
Greetings
AND BEST
WISHES

Helpful Hints

As you now know, calligraphy is a skill that you can learn with practice. It's important to continue practicing on a regular basis in order to improve your letterforms. But practice alone is not enough; to master the art of beautiful lettering it is extremely helpful to have a good teacher and to share ideas and information (network) with other lettering artists. Sign up for a class and join your local calligraphy society.

There are many calligraphy societies around the country (and the world!) which offer workshops, newsletters and information of interest to those in the field. If you don't know where to find a calligraphy teacher or group in your area, call a calligrapher who is listed in your yellow pages. Or write to one of the larger calligraphic societies listed in the column on the right.

It's important to look at examples of good lettering as often as you can. Study signs, invitations, book jackets, calendars, greeting cards, and magazine and newspaper advertisements. Photocopy your favorites and start a file of lettering samples you especially like.

A library of calligraphic books will also be an excellent resource for you. When you are ready to start learning other calligraphic alphabets and styles, be sure to get a copy of the 22nd edition of the Speedball Textbook, which is a comprehensive guide to pen and brush lettering.

Another way you can improve your calligraphic skills and learn things of interest to lettering artists is to subscribe to the magazine dedicated to the calligraphic arts: Letter Arts Review, 1624 24th Ave. SW, Norman, OK 73072. 1-800-348-PENS.

Your calligraphy society should be able to provide a list of local book and art supply dealers or mail order suppliers. For more information about societies, supplies and dealers, and a free calligraphy brochure, contact Hunt Manufacturing. 1-800-TRY-HUNT.

CALIFORNIA
Friends of Calligraphy, Inc.
P.O. Box 425194
San Francisco, CA 94142-5194

Society for Calligraphy
P.O. Box 64174
Los Angeles, CA 90064

FLORIDA
The Scribes of Central Florida
P.O. Box 1753
Winter Park, FL 32790

ILLINOIS
Chicago Calligraphy Collective
P.O. Box 11333
Chicago, Il 60610

IOWA
Calligraphic Arts Guild
c/o Cheryl O. Adams
2124 NW 139th Street
Des Moines, IA 50325-8725

NEW YORK
Society of Scribes, Ltd.
P.O. Box 933
New York, NY 10150

OREGON
Portland Society for Calligraphy
P.O. Box 4621
Portland, OR 97208

PENNYSLVANIA
Philadelphia Calligraphers'
Society
P.O. Box 7174
Elkins Park, PA 19117

TEXAS
Houston Calligraphy Guild
c/o Art League of Houston
1953 Montrose Blvd.
Houston, TX 77006

WASHINGTON D.C.
The Washington
Calligraphers Guild
P.O. Box 3688
Merrifield, VA 22116

Acknowledgements

ABOUT THE AUTHOR

Joanne Fink, noted designer, teacher and writer, works out of her studio, Calligrapher's Ink, in

Lake Mary, Florida. Since graduating from the University of Pennsylvania in 1981, Joanne has pursued her lifelong interest in lettering. She specializes in designing greeting cards and other products for the stationery and gift industries. Joanne lectures widely and has written several books including: *Lettering Arts* (with Judy Kastin), *Greeting Card Design*, and the *22nd Edition of the Speedball Textbook.*

ABOUT THE CALLIGRAPHER

Cheryl O. Adams' business, Adams Art, specializes in calligraphy. Her lettering is seen on

book covers and in national magazines, as well as in promotional and advertising materials for national restaurant chains, airlines and other companies. With a masters degree in Curriculum and Instruction, Cheryl teaches calligraphy classes and speaks throughout the U.S. to calligraphy guilds and other groups as well as at International Calligraphy Conferences. Her lettering has appeared in many publications including *Calligraphy Review, Calligraphers Engagement Calendars, The Speedball Textbook* and other books.

THANK YOU

Special thanks to • Maura Cooper • • Deborah Cunningham • Janet Hoffberg • • Judy Kastin • Leslie Kane • Robert Santiago • • Andy Trattner • Lance Turner • and Julian Waters • for their help and advice.

DEDICATION

To my wonderful husband and partner, Andy Trattner, with love. — J.C.F.

To my best friend and top-of-the-line husband, Garth. — C.O.A.

Pen Patterns

Use either the Elegant Writer® Broad or Scroll point,
or the Panache® Broad point for this exercise.

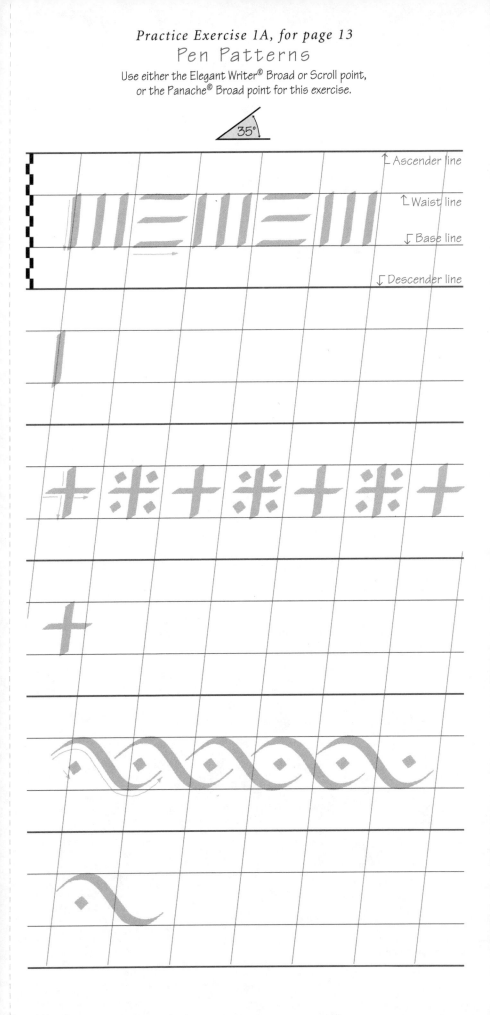

Pen Patterns

Use either the Elegant Writer® Broad or Scroll point,
or the Panache® Broad point for this exercise.

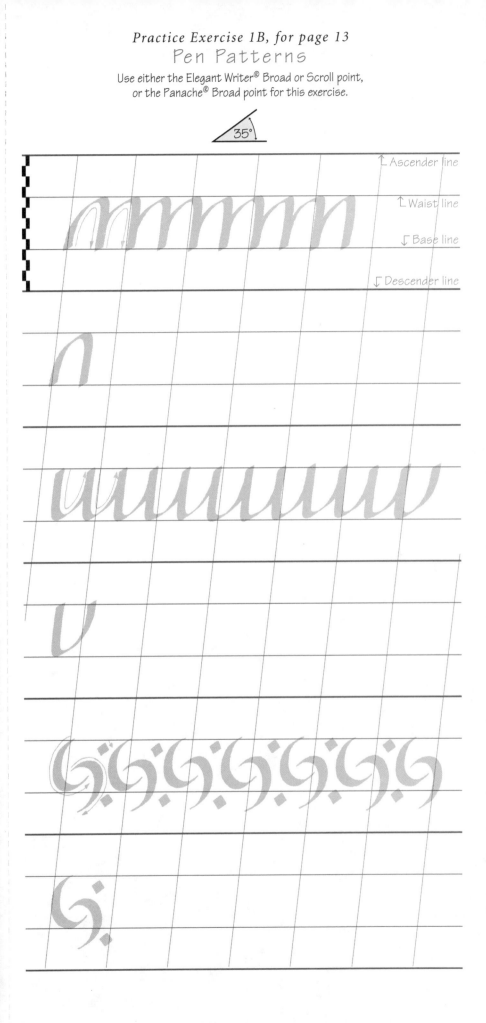

↑ Ascender line

↑ Waist line

↓ Base line

↓ Descender line

Italic Lower Case - Straight

Use either the Elegant Writer® Broad or Scroll point,
or the Panache® Broad point for this exercise.

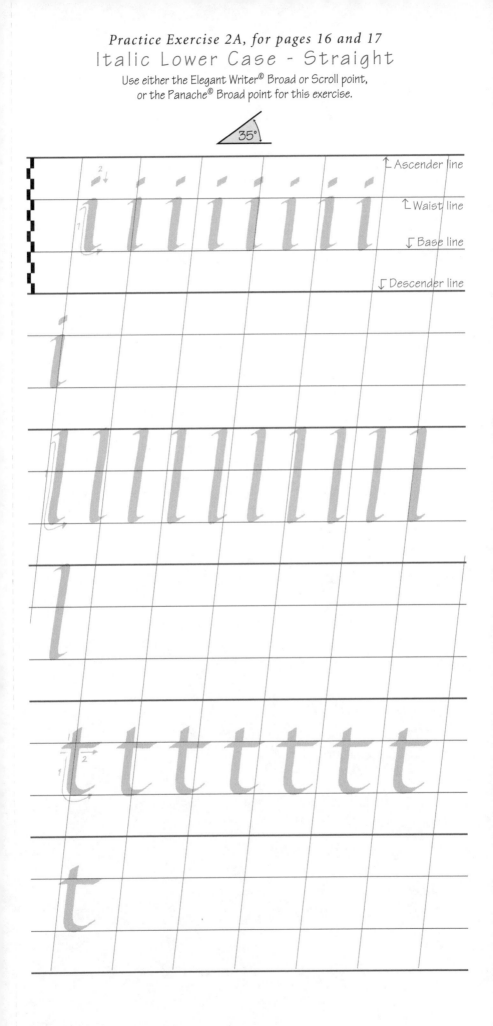

Italic Lower Case - Straight

Use either the Elegant Writer® Broad or Scroll point,
or the Panache® Broad point for this exercise.

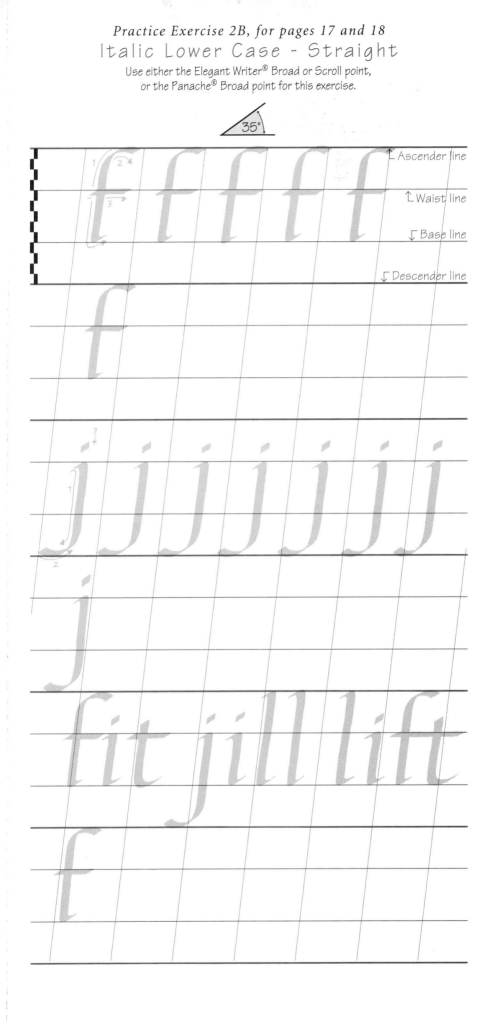

35°

Ascender line
Waist line
Base line
Descender line

Use either the Elegant Writer® Broad or Scroll point,
or the Panache® Broad point for this exercise.

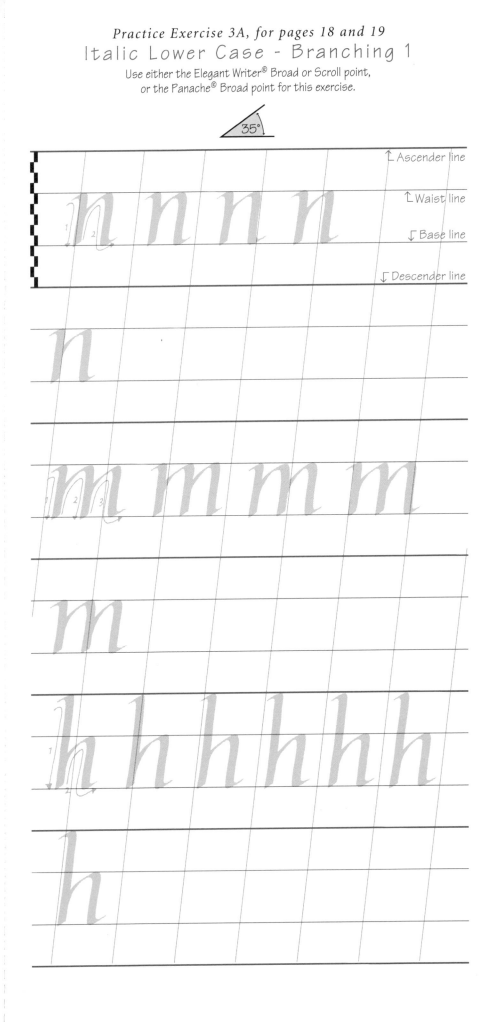

35°

↑ Ascender line

↑ Waist line

↓ Base line

↓ Descender line

Italic Lower Case - Branching 1

Use either the Elegant Writer® Broad or Scroll point,
or the Panache® Broad point for this exercise.

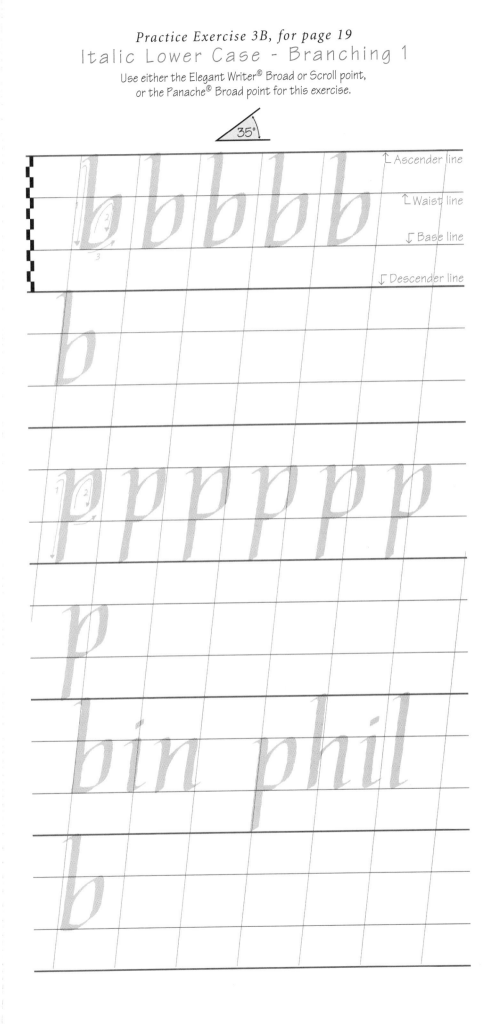

↥ Ascender line

↥ Waist line

↳ Base line

↳ Descender line

Italic Lower Case - Branching 1

Use either the Elegant Writer® Broad or Scroll point,
or the Panache® Broad point for this exercise.

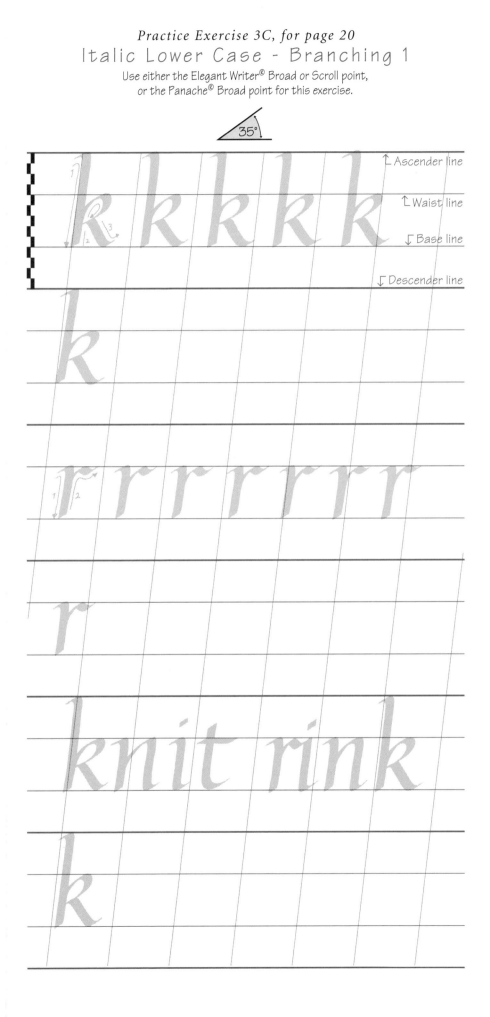

Practice Exercise 4A, for pages 20 and 21
Italic Lower Case - Branching 2
Use either the Elegant Writer® Broad or Scroll point,
or the Panache® Broad point for this exercise.

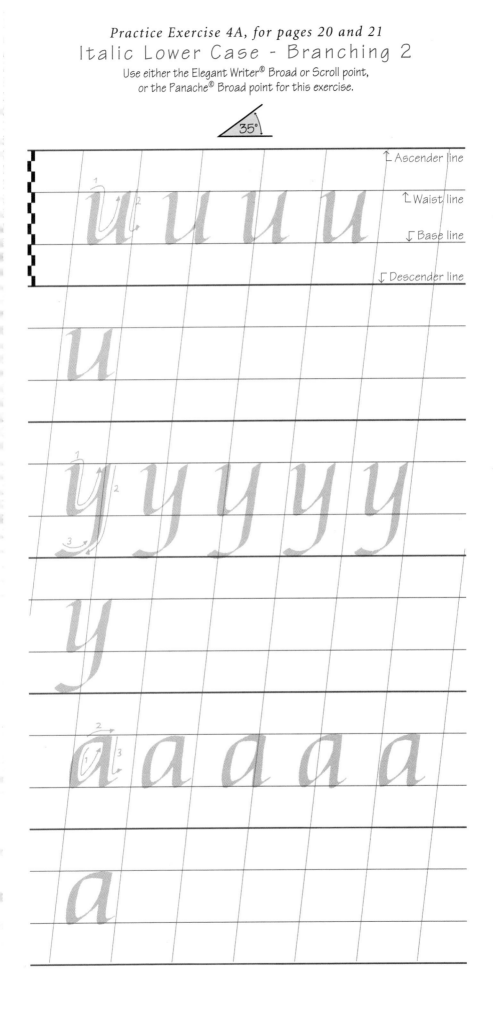

Italic Lower Case - Branching 2

Use either the Elegant Writer® Broad or Scroll point,
or the Panache® Broad point for this exercise.

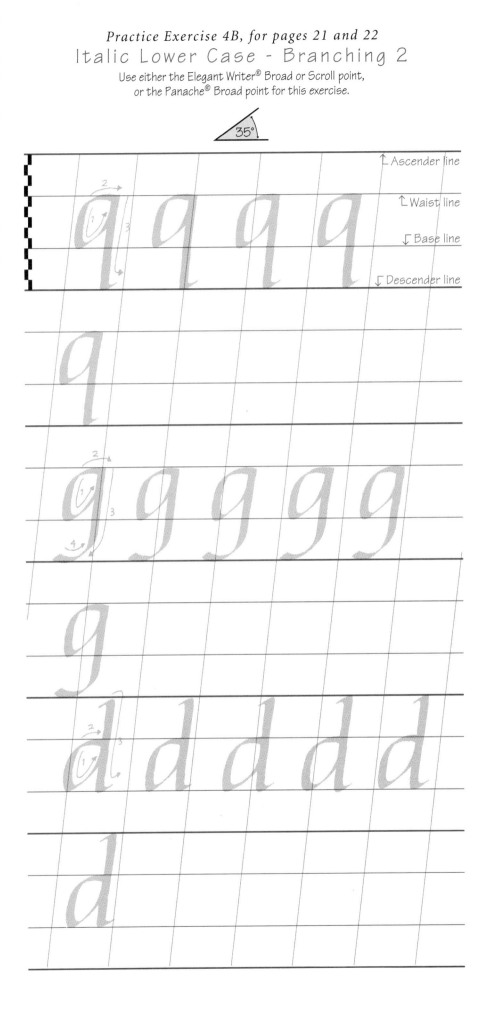

35°

Ascender line
Waist line
Base line
Descender line

Italic Lower Case - Elliptical

Use either the Elegant Writer® Broad or Scroll point,
or the Panache® Broad point for this exercise.

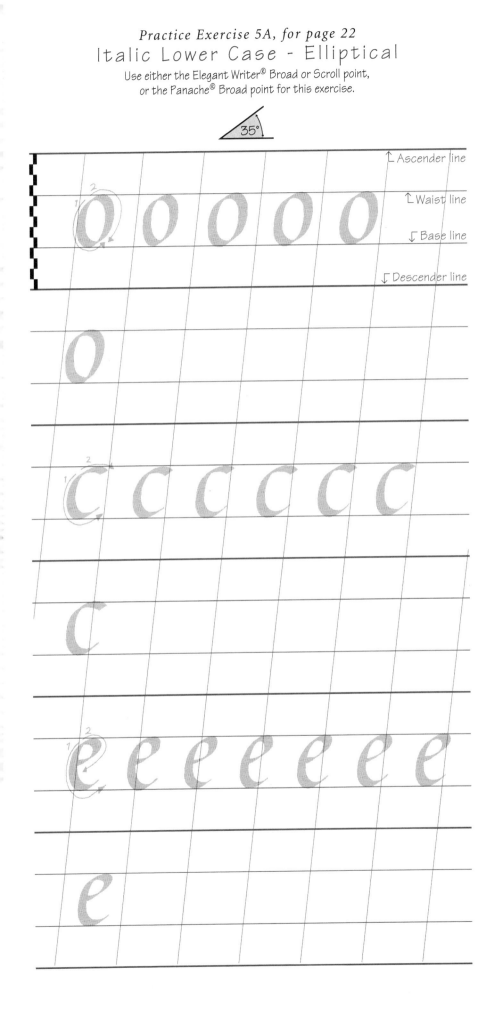

35°

↑ Ascender line

↑ Waist line

↓ Base line

↓ Descender line

Italic Lower Case - Diagonal

Use either the Elegant Writer® Broad or Scroll point,
or the Panache® Broad point for this exercise.

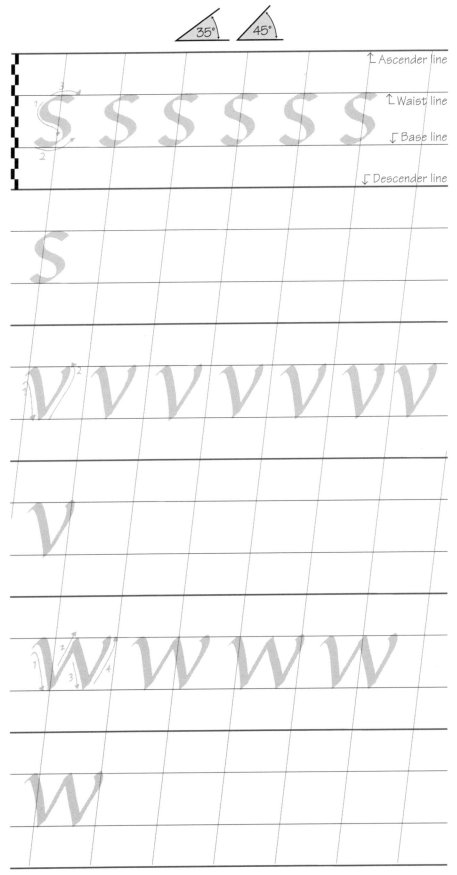

↑ Ascender line

↑ Waist line

↓ Base line

↓ Descender line

Italic Lower Case - Diagonal

Use either the Elegant Writer® Broad or Scroll point,
or the Panache® Broad point for this exercise.

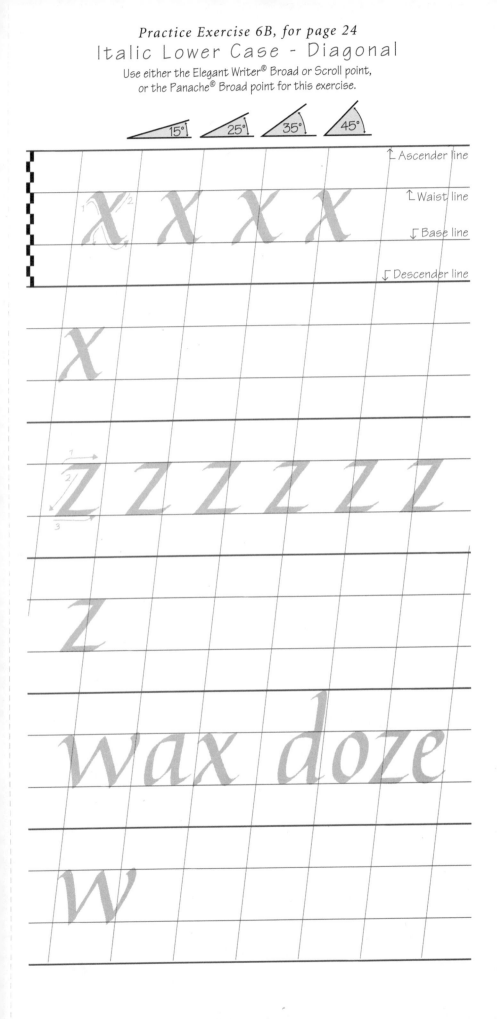

15° 25° 35° 45°

⌐ Ascender line

⌐ Waist line

⌐ Base line

⌐ Descender line

Abecedarian Sentence

Use either the Elegant Writer® Broad or Scroll point,
or the Panache® Broad point for this exercise.

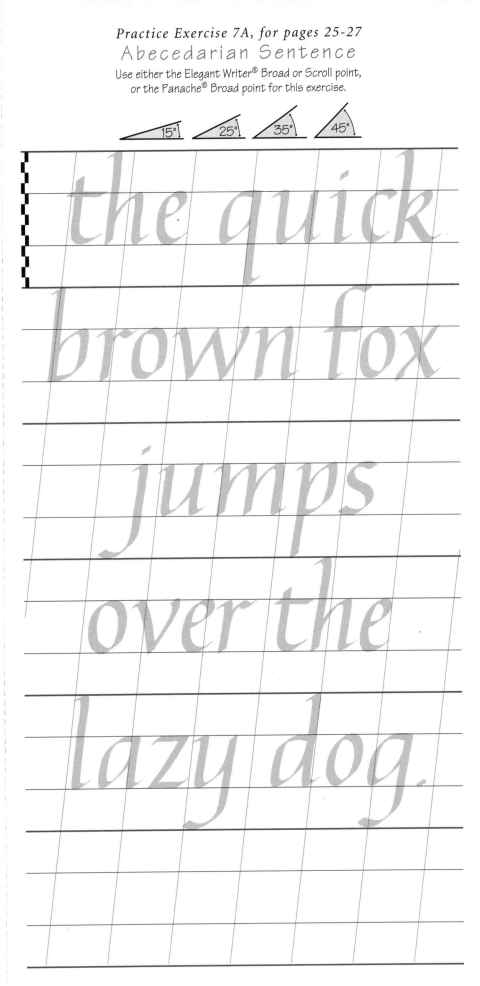

15° 25° 35° 45°

the quick

brown fox

jumps

over the

lazy dog.

After tracing this sentence write it again on practice exercise 7B.

Practice Exercise 7B, for pages 25-27

Abecedarian Practice

Use either the Elegant Writer® Broad or Scroll point,
or the Panache® Broad point for this exercise.

Italic Capitals - Straight

Use either the Elegant Writer® Extra-fine point, or the Panache® Medium point for this exercise.

Italic Capitals - Straight

Use either the Elegant Writer® Extra-fine point, or the Panache® Medium point for this exercise.

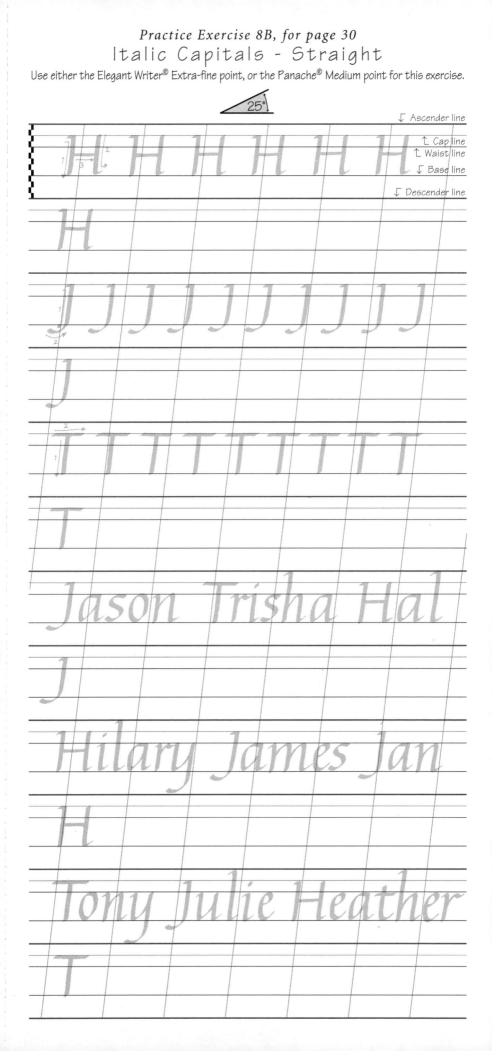

↘ Ascender line
↖ Cap line
↖ Waist line
↘ Base line
↘ Descender line

H H H H H H H H

H

J J J J J J J J J

J

T T T T T T T T

T

Jason Trisha Hal

J

Hilary James Jan

H

Tony Julie Heather

T

Italic Capitals - Bowl

Use either the Elegant Writer® Extra-fine point, or the Panache® Medium point for this exercise.

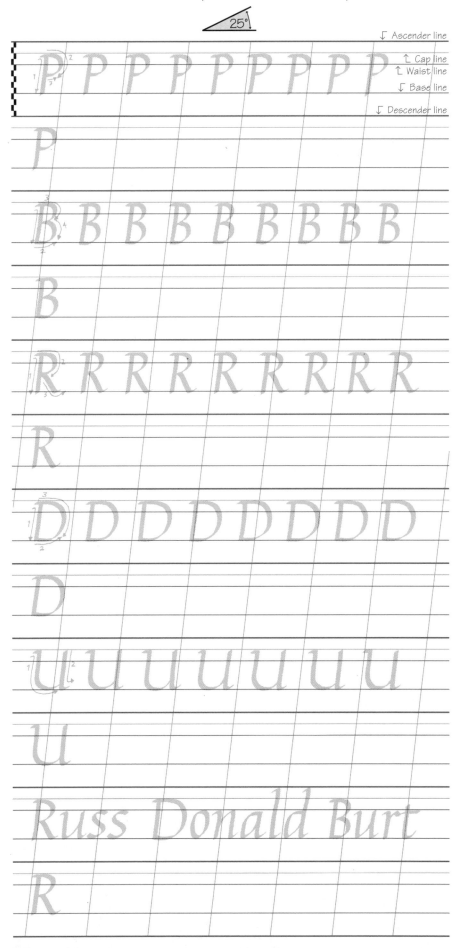

↓ Ascender line
↑ Cap line
↑ Waist line
↓ Base line
↓ Descender line

Russ Donald Burt

Italic Capitals - Round

Use either the Elegant Writer® Extra-fine point, or the Panache® Medium point for this exercise.

25°

↓ Ascender line

O O O O O O

↑ Cap line
↑ Waist line
↓ Base line

↓ Descender line

O

Q Q Q Q Q Q Q

Q

C C C C C C C C

C

G G G G G G G

G

Courtney Garth

C

Opal Quincy Cody

O

Practice Exercise 11A, for pages 33-35
Italic Capitals - Diagonal
Use either the Elegant Writer® Extra-fine point, or the Panache® Medium point for this exercise.

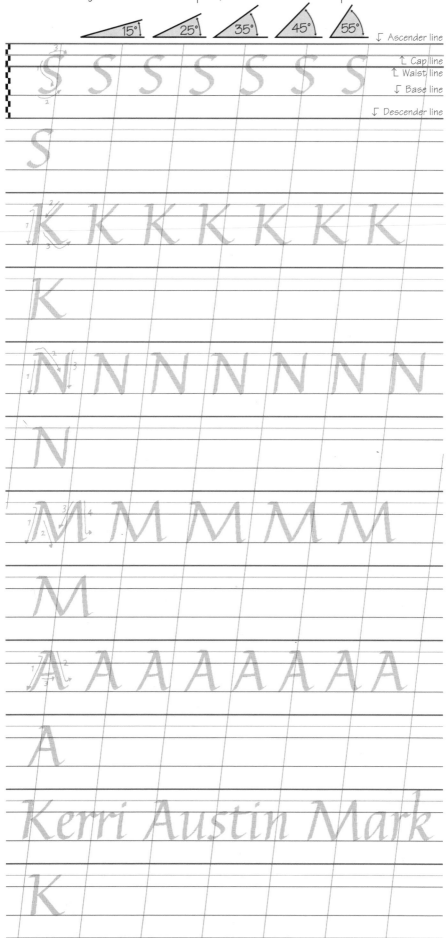

15° 25° 35° 45° 55°

↓ Ascender line
↑ Cap line
↑ Waist line
↓ Base line
↓ Descender line

S S S S S S

S

K K K K K K K

K

N N N N N N N

N

M M M M M M M

M

A A A A A A A A

A

Kerri Austin Mark

K

Italic Capitals - Diagonal

Use either the Elegant Writer® Extra-fine point, or the Panache® Medium point for this exercise.

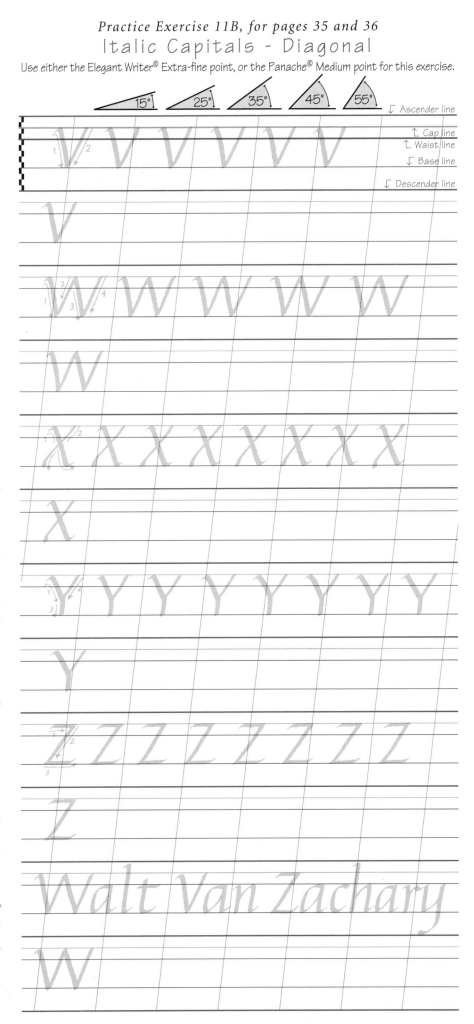

Italic Lining Guide 1

For use with the Elegant Writer® Broad or Scroll point, or the Panache® Broad point.

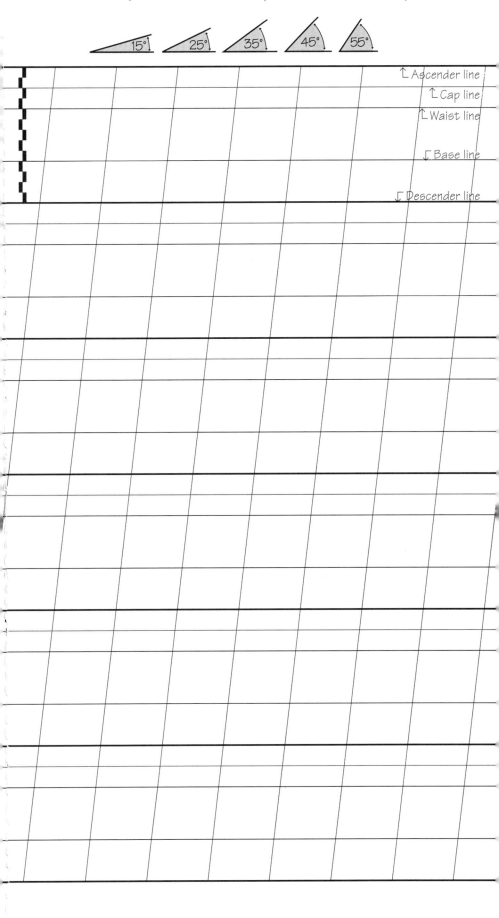

15° 25° 35° 45° 55°

⌐ Ascender line
⌐ Cap line
⌐ Waist line
⌐ Base line
⌐ Descender line

Italic Lining Guide 2

For use with the Elegant Writer® Medium point.

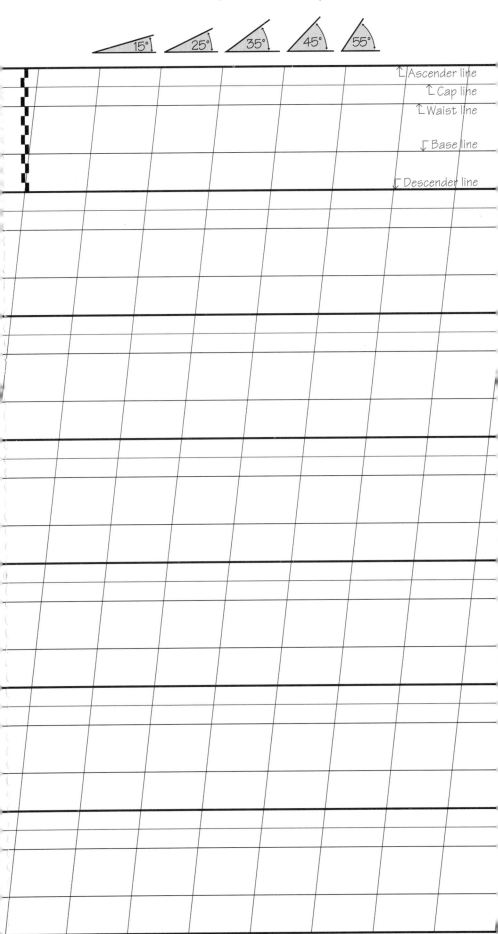

15° 25° 35° 45° 55°

↑ Ascender line
↑ Cap line
↑ Waist line
↓ Base line
↓ Descender line

Italic Lining Guide 3

For use with the Elegant Writer® Fine point.

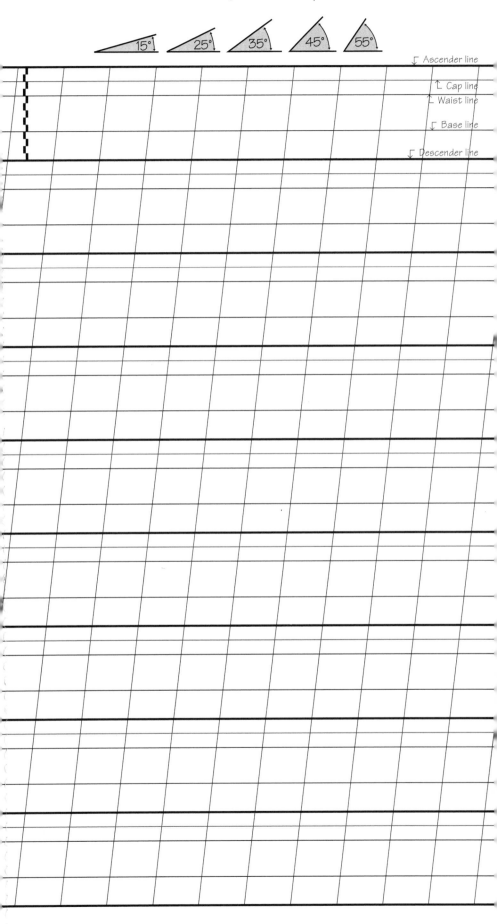

15° 25° 35° 45° 55°

Ascender line
Cap line
Waist line
Base line
Descender line

Italic Lining Guide 4

For use with the Elegant Writer® Extra-fine point, or the Panache® Medium point.

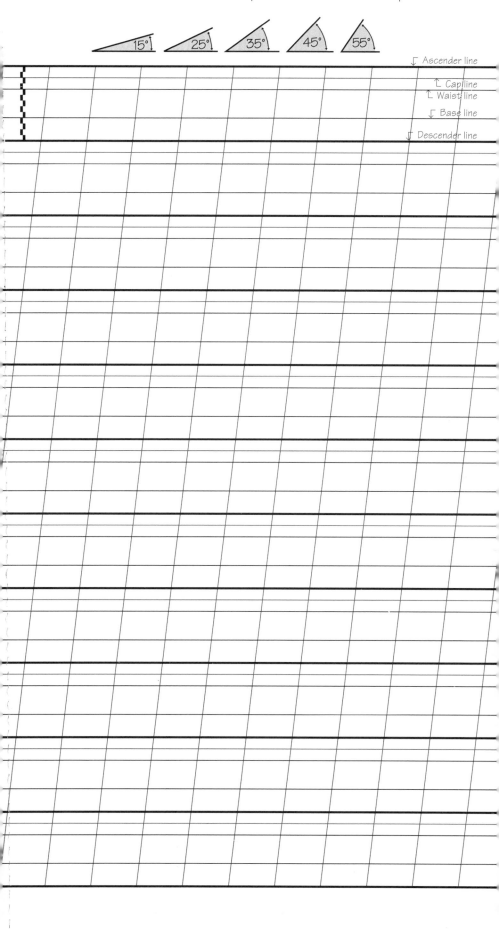

Italic Lining Guide 5

For use with the Panache® Extra-fine point.

Envelope Liner 1

For use with the Panache® Extra-fine point.

15° 25° 35° 45° 55°

Cut out the Envelope Liner and slip it into an envelope
or use a light box and lay envelope on top.

Envelope Liner 2

For use with the Elegant Writer® Extra-fine point, or the Panache® Medium point.

15° 25° 35° 45° 55°

Cut out the Envelope Liner and slip it into an envelope
or use a light box and lay envelope on top.